Seascapes and Landscapes

Course of Drawing and Painting

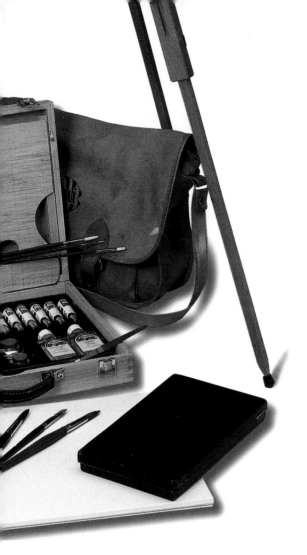

Author: Josep Casals
Artists: Badalona Ballestà, Rogelio Urgell, Julia Romero
Editor: Nacho Asensio
Coordination & texts: Rosa Tamarit
Translation: Bill Bain
Graphic design & Layout: David Maynar / Mar Nieto

Copyright © 2004 Atrium Group
Published by:
Atrium Group de ediciones y publicaciones S.L.
Ganduxer, 112
08022 Barcelona

Tel: +34 932 540 099
Fax: +34 932 118 139
e-mail: atrium@atriumgroup.org
www.atriumbooks.com

ISBN: 84-96099-63-6
Legal Dep.: B-47.142/2004

Printed in Spain
Ferré Olsina S.A.

Contents

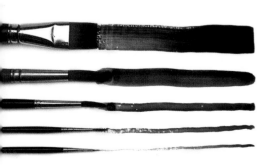

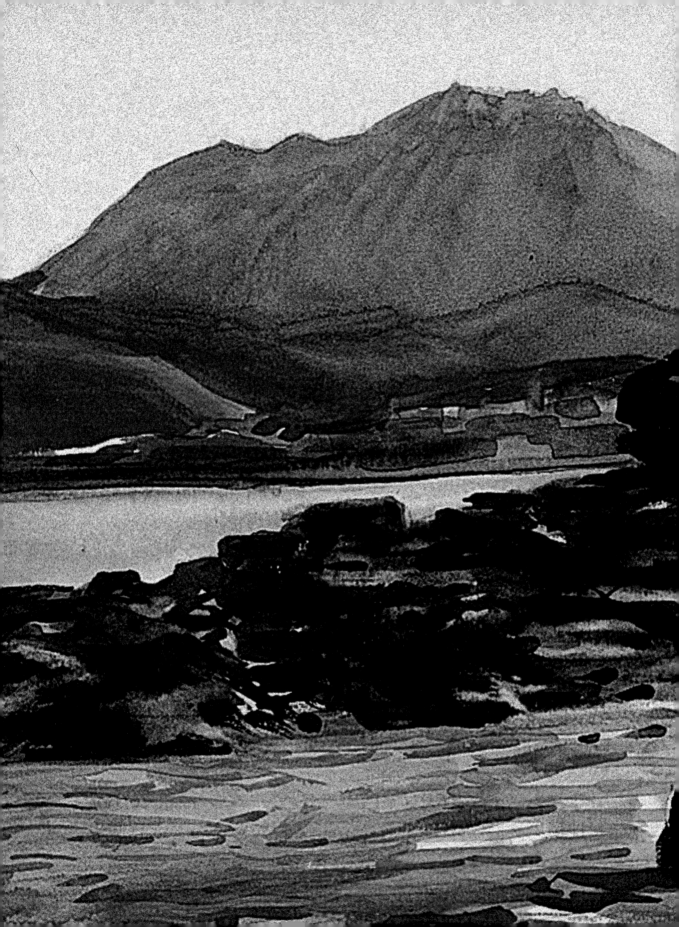

Introduction

This book aims to approach in a clear and simple way two of the techniques most commonly used in the world of Drawing and Painting: Seascapes and Landscapes. Both are approached from the point of view of the beginner, concentrating on the subjects that are easiest to achieve.

Within the landscape genre, seascapes are one of the most attractive techniques for those who want to depict the sea in their work. In most cases we don't have it close at hand; a photograph or a picture may be the everyday helps we use for inspiration. Landscape is regarded as one of the simplest artistic techniques to master. Any beginner can do landscapes in his first steps in painting, because the technique involved has none of the precision found in other specialties such as still life or figure painting. You only need the basic notions of framing and composition.

That is why we encourage you to explore this book, which is full of practical examples. We're sure they will help you to develop that artistic streak you've got hidden away.

1 Landscape

Landscape is one of the most absorbing fields of painting you can get to learn. Any person beginning to paint can achieve passable landscapes with just a few notions, including those of framing and composition.

Composition in landscape

It seems natural to regard landscape as being easier than other artistic subjects, because the things you depict in it usually lack the preciseness of still life or the complexity of figure painting.

In landscape, complexity can take in as much as the artist wants, or perhaps rather as much as his artistic talents can cope with. In principle, there's no need to tackle any unduly complicated matters, but it is necessary to examine a few which are basic.

Painting landscapes in the open air is one of the keenest pleasures a painter can enjoy.

This unit will cover framing and composition as basic skills for making a landscape, but we begin by showing some of the materials that are necessary for the landscape painter. These include folding easels, accessories highly appreciated by artists who like to paint out of doors.

PAINTING OUT OF DOORS

Artists have not always gone out into the open air to paint. It was the fore-runners of Impressionism (grouped in what is called the Barbizon School, led by the French painter Théodore Rousseau about 1840) who promoted painting out of doors, thus getting away from the so-called "historical landscape". Until then painters used to work in the studio.

Nowadays there are many artists who relish going out into the open air to work in the heart of nature. The materials you need for painting out of doors are minimal, but they are absolutely necessary.

FIELD MATERIALS

Any painting technique is suitable for painting landscape in the midst of nature. Whichever one the artist chooses, there will always be certain essential materials. For example, to paint in oils you will need a palette-box, brushes, charcoals and a block of paper. The folding easel is an indispensable piece of equipment. You need a suitable bag to carry the materials.

The field materials are essential to enable you to work comfortably. Besides paints, you need to carry certain minimum accessories.

The notebook

One of the most valuable tools for the landscape painter is a notebook. It is not always possible to carry all your painting implements; a small notebook however takes up very little space and can be used at any time to make a note of color or simply to jot something down in pencil.

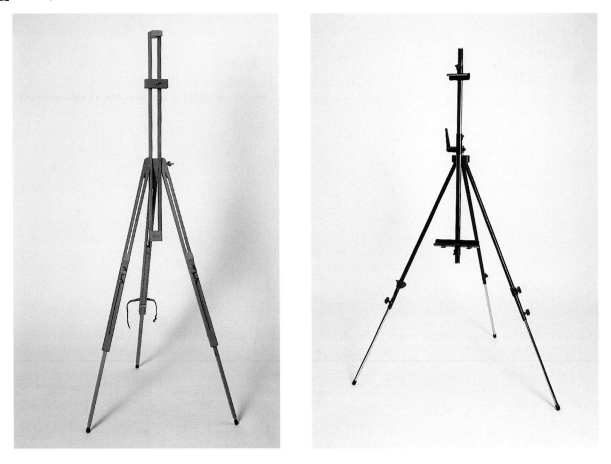

An easel is absolutely necessary if you want to paint a landscape comfortably. It is a useful tool for all drawing and painting techniques, and is practically essential for painting in oils or water-colors. There are easels of many types; for the landscape painter the best is the folding model, as it takes up very little space and can be carried in a bag with the other materials. Easels can be wooden or metal (left and right picture respectively); the wooden one is always rather sturdier, and is more suitable for painting middle-sized formats.

THE RULE OF GOLDEN SECTION

In the search for harmony in composition, one of the classical principles par excellence is what is called the rule of golden section. Under this term, which may sound rather pretentious, lurks one of the few technical rules that offer a guide to every type of composition you will want to make within your picture frame.

Why do we apply the rule of golden section to landscape? Very simple. Even though landscape is in many ways a more manageable subject than others, composition in it is not as simple as it might seem. In still life or in figure drawing, the compositional elements are very clear and the structure can be built up very easily. In landscape by contrast the compositional elements are much less specific; sometimes you have to find them in the line of the horizon, in a lane or in a tree.

The rule of golden section consists in a series of divisions which are applied geometrically in composing or framing a picture. These divisions mark the points of interest according to the format chosen.

COMPOSITION WITH THE RULE OF GOLDEN SECTION

The rule of golden section is a good guide to bear in mind in composing a landscape, but you won't need to make the compositional diagram every time. With practice you develop your own taste in composition, and get to the stage of working out intuitively both the framing and the composition of the elements you are painting.

The view that you pick as your subject may be a wide and inclusive one; but as you look round at the landscape, you need to choose a section of it with a certain

rigor as to composition and framing, searching within the whole for the elements that are going to form the foreground and the planes beyond in a balanced and harmonious way.

The form of the landscape needs to be chosen according to a criterion of order and harmony; with the rule of golden section it is easy to find a harmonious composition.

DIFFERENT POSSIBILITIES OF INTERPRETATION

The first line always defines the completed whole. Starting from the line of the horizon, you situate the different elements of the landscape. The inclusion of a larger or smaller share of sky within the frame allows you in its turn to decide what proportion of ground you are going to paint. But the elements of composition don't just consist in dividing the space between the area of the sky or the earth; a balance between the different objects of the picture is also achieved with any element that may be included within the compositional frame. The point of view allows the landscape shown to be situated according to the viewer's angle of sight. If you paint a landscape with a slightly tilted line of sight, there is a noticeable reduction in the amount of sky in the frame, and the ground gains in proportion.

The first line always defines the completed whole. Starting from the line of the horizon, you situate the different elements of the landscape. The inclusion of a larger or smaller share of sky within the frame allows you in its turn to decide what proportion of ground you are going to paint. But the elements of composition don't just consist in dividing the space between the area of the sky or the earth; a balance between the different objects of the picture is also achieved with any element that may be includ-

How to calculate the rule of golden section

The rule of golden section is based on the square, and the proportion of its side within the rectangle. To obtain it you can follow these steps:

1. Draw a square

2. Draw the diagonals of the square to find its center.

3. Draw a vertical line dividing the square into two.

4. Draw an arc from the top of this line to the base of the square.

5. Draw a vertical line upward from the end of the arc; this will be the height of the golden rectangle.

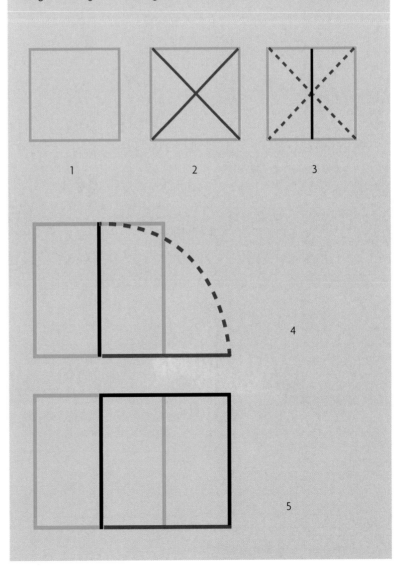

9

ed within the compositional frame. The point of view allows the landscape shown to be situated according to the viewer's angle of sight. If you paint a landscape with a slightly tilted line of sight, there is a noticeable reduction in the amount of sky in the frame,and the ground gains in protion.

A LINE CAN BE A LANDSCAPE

The line can be as simple or as complex as the artist wants. A simple line locates a clear difference between the sky and the earth; the drawing of a single stroke begins the process of composing the landscape. The first stroke usually lays down the first separation of the basic planes of the landscape; it doesn't need to be too precise, but it will mark the difference between each of the elements. Thus, as you can see in the lower images of the previous page, a white horizontal line can be drawn in crayon on a blue paper. This line can be placed high or low; if it is set very low, the proportion of sky will be higher than that of the land. If it is set very high, the land will dominate in the picture. Whichever you choose, you need to avoid having the line of the horizon half-way up the picture, which would give a symmetrical, boring composition.

Once the main line has been situated, the picture can be completed with whatever elements you think necessary. In this example, after the drawing of the first line, a very off-center path has been drawn, and this has been painted around with white and sky blue; the path has been painted in dark green crayon, and likewise the trees.

WITH A FEW STAINS EVERYTHING IS SUGGESTED

In painting a landscape, the color-stain becomes a crucial matter. Painting, even when treated in the most realistic manner, always remains an interpretation, as it is impossible to paint or draw

With these few simple lines a mountain landscape with a very low point of view has been sketched; the mountains become the important element.

An off-center tree has been drawn close up to give a visual reference and thus establish the planes of depth.

absolutely everything you see. A view has to be thought of as a whole, not as a series of separate elements which would be interminable to list.

When you observe a landscape, you see many things, too many elements to be transferred with the brush or pencil onto paper. You therefore need to make a synthesizing effort so as to capture the essence.

A SIMPLE EXERCISE

There is a very simple way to see the different elements of the landscape as a homogeneous whole, discarding the unnecessary details which can obscure rather than help to understand what you see. Just look at the landscape with eyes half-shut or try to unfocus your sight. The shapes lose definition, the outlines blend together, and the detail which was excessive before loses its importance. These are the shapes which you need to interpret in your drawing and painting.

This composition has been made starting from a horizon line placed in an intermediate position, neither too high nor very low. It has then been finished with very simple elements, also off-center but with an eye to balance.

OVERLAYING PLANES

Once you have chosen the right point of view, you need to consider thoroughly the compositional possibilities offered by the picture. Sometimes a balance between the various objects in the landscape can prove too monotonous. When there are too many horizontal shapes, without elements to balance an excessive symmetry, it is advisable to seek other compositional solutions to add dynamism to the landscape as a whole. A simple tree situated strategically in the composition can give strength to the whole and at the same time establish a visual point of reference against the background. The overlaying of different objects in the landscape is a device very often used to counteract too much symmetry, but it is also very useful for establishing planes of depth without the need to apply any technique of perspective. The rule to bear in mind is simple: the larger a familiar object is shown (a tree, a fence, a house etc.), the nearer it is to the viewer and the further it is from the planes beyond it.

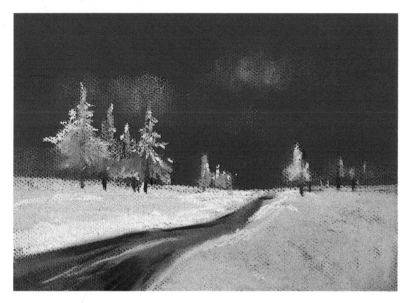

Tackling a landscape directly may prove overwhelming because of the quantity of details it contains.

Just half-close your eyes and unfocus the sight for the details to meld into the whole and the shapes to blend.

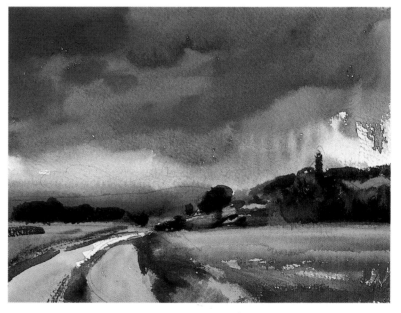

Thinking of a landscape as stains of color makes its understanding much easier. Compare this water-color picture with the two previous images.

2 Landscape: trees

Each one of the elements making up a landscape has equal importance in the picture; for this reason, the artist needs to learn to depict them with different artistic techniques. This applies to trees.

Trees

In studying a landscape it is very important to pay attention to the individual elements that compose it. This unit concentrates on the landscape genre in the depiction of trees, a particularly attractive subject because it allows a certain freedom compared with the rigor of other more complex questions.

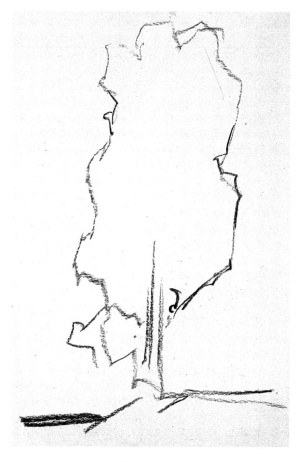

A tree can be framed on the basis of a simple rectangle and its vertical axis.

As the beginner will easily see, showing one tree a little bigger or smaller than other trees there may be in a landscape is not as important as if one drew one arm shorter than another in figure drawing.

Trees are a particularly pleasant subject to paint, but that doesn't mean that the subject is trivial; it demands of the artist a certain effort, in both composition and balance. This unit will present the basic structure of a tree and will also study a series of examples created using different pictorial techniques.

THE PLAN OF THE TREE

Trees are not amorphous things; their structure reflects a well-planned composition which, like the other elements in nature, can be fitted into a geometrical framework of simple forms. If you start from a good initial plan, you will find it much easier to build up any tree, however complicated it may seem.

THE GENERAL STRUCTURE

Whether it has leaves on it or not, a tree is built up from an axis which can be clearly distinguished from the details that complete it; that axis is the trunk. From the trunk the branches spread out, often acquiring fantastical shapes. When drawing a tree, the beginner needs to observe carefully the overall shape and seek in his drawing a geometrical figure in which to fit the whole; for example a rectangle. This simple shape is repeated as many times as necessary. Within the

Three tips and a master example

• The first strokes should be made without pressing too hard, so as to produce light grays.

• Wipe your fingers on the cloth after toning with a charcoal stump, so as to avoid staining the white parts of the paper.

• Sometimes the charcoal stump fails to draw and scratches a brown line on the paper; when this happens, either use a new charcoal or rub the defective one on a piece of paper until it draws with its natural strokes.

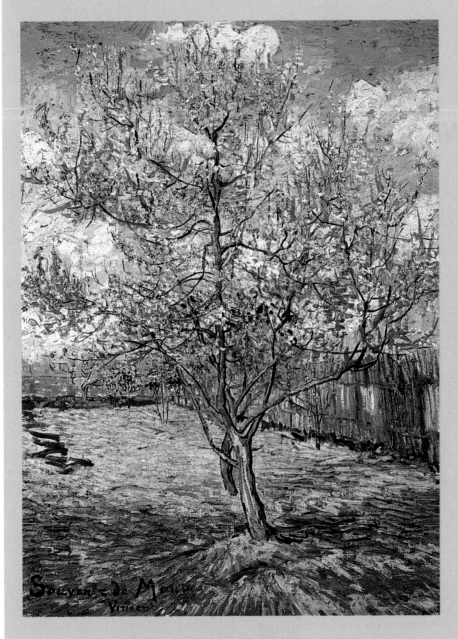

Vincent Van Gogh (1853-1890) is one of the most controversial painters in history. His work passed almost unnoticed and his unstable personality kept him on the verge of insanity. Even so many contemporary trends in art would not exist but for him. Trees were one of this brilliant artist's favorite subjects. The work of Van Gogh is energetic and full of feeling. His mastery does not spring from any great virtuosity as a draftsman, but from an extraordinary force which can be seen in the way he uses color and applies strokes to the canvas. As one can see in the way this Flowering Pink Peach-Tree is painted, the artist manages to capture the vibration of the flowered branches which blend into the atmosphere around them.

As can be seen in this detail, the surface of the paper remains perfectly visible after the stroke has been applied.

The stroke with the tip is followed by a flat cross-stroke, not pressing too hard.

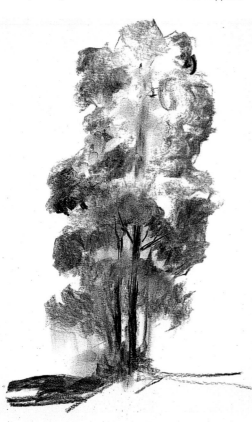

The darker grays enable the definitive forms to be outlined. Notice the way the two trunks have been sketched.

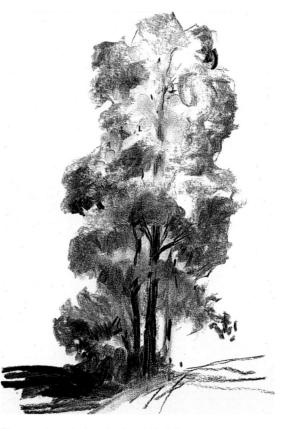

The more important contrasts, which define the shape of the tree, are done with the point of the charcoal.

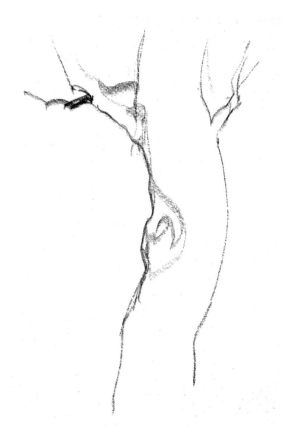

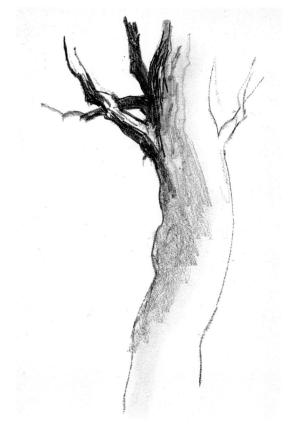

This trunk is depicted with a very simple drawing. A single stroke is enough to develop its entire shape.

The dark shading is handled like in a geometrical figure, although it is easier to draw a trunk than a cylinder.

framework the main lines are built up, starting from the axis formed by the trunk. These first lines do not need to be definitive, just a sketch to anchor the later drawing.

With this first exercise the beginner learns to draw a tree in charcoal, which will serve as a basis for painting in any other artistic technique.

This is a very simple task and presents no problems. Though the results you obtain may not be identical in proportions to the model shown, the drawing will certainly be a tree.

THE SKELETON OF THE TREE

Within the rectangular framework, draw the outline of the tree-top with the tip of the charcoal stump, which allows a looser and freer stroke than the flat; this exercise does not call for very precise shapes. The tree-trunk however does require greater precision, so here you should use the flat of the stump lengthways to the stroke.

From this we see the basic principle that we use a particular kind of stroke for each part of the drawing.

Begin the stroke on the left of the tree, with the charcoal stump flat and sideways on to the stroke; in this way when you draw the stump over the paper it stains the paper with its whole length.

On the right of the tree, with a flat cross-ways stroke, go over the previous drawing done with the tip of the stump. First, draw with very soft lines, then draw over the outline of the tree more strongly: you get a rather darker gray than before.

You don't need to draw the whole crown of the tree; leave some areas unstained, so that the surface of the paper is left to breathe. These brighter areas are the shinier parts of the foliage.

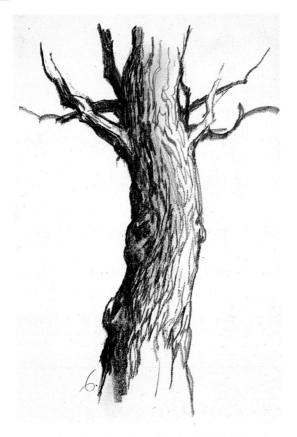

Once the whole right side of the tree has been built up, you can tone the edges of the strokes so that they don't stand out too much: softly pass your finger over them and extend the charcoal towards the clean area of the paper.

CONFIRMING THE INITIAL STRUCTURE

Once the main grays have been located on the initial structure, you can go on to the contrast of the tree-top. For this area, use different lengths of charcoal; in that way the flat and cross-strokes acquire different lengths. In the darker shadows, the stroke must be firmer. In the areas which need to show denser grays, such as the shadow on the ground, use the tip of the charcoal, and also to bring out in contrast the right side of the trunk.

To increase the quality of the details, you need to achieve grays of more density and contrast. Draw the trunk of the trees with the point, with the charcoal in the palm of the hand as if it were a pencil; the strokes produced are very strong ones and permit fine lines which allow the lighter background of the paper to breathe between them.

The branches of the tree are likewise drawn with the point of the charcoal, although not all the work of the foliage is done in the same way; on the right side, go over the drawing again with the flat of the charcoal.

With small strokes, the texture of the trunk is finished, paying attention to the different intensities of the dark areas and the shape of the tree's outline.

The denser contrasts of the crown are finished with the stump flat and cross-ways, but not all the shadows are made in the same way. Notice in the finished drawing how the lower part of the shadow has been made darker by means of firm strokes with the point.

THE TRUNK OF THE TREE
ITS VOLUME

In the previous drawing unit you acquired sufficient notions of shading to draw simple volumes, such as the trunk of a tree. It is not always necessary to draw or paint the volume of a trunk, for generally in a landscape trees are depicted at a distance, permitting a unified texture. Nevertheless in many cases it may be necessary to place a tree in the foreground. You may paint a landscape with trees where no particular element stands out, for example an arboretum, but when the tree is in the foreground, and with the appropriate lighting, you will need to depict its texture.

FRAMING THE SHAPE

A tree trunk in the foreground may form a very important compositional element in a landscape, and may also present a series of connotations of changes of rhythm in the lighting of the picture. This aspect will be studied later on.

The interpretation made in this exercise will be an essential one in any of the drawing or painting procedures to be used later on for depicting elements of the landscape.

We advise the beginner, after he has completed this exercise in charcoal, to try doing it with other materials he knows. You can do the exercise with any drawing technique, for they are all based on obtaining dark shades for the shadows and the absence of them to indicate areas of light.

The most important thing at the beginning is the framing, for it is the basis from which the internal parts of the trunk are going to be included, defining both their texture and the different areas of light or shadow.

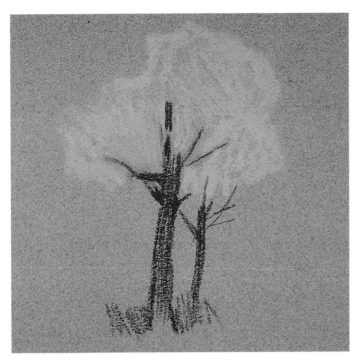

Medium-grain paper is very suitable for painting trees in crayon, as it lends itself to any stroke without the texture of the support being lost.

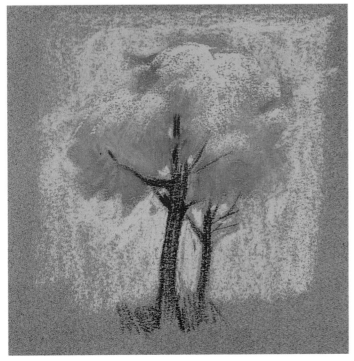

Fine-grain paper allows the surface texture to be ignored. The most suitable one for painting trees is one with a rather rough texture.

SUGGESTING VOLUME

The trunk of a tree has a cylindrical shape, and it can therefore be modeled with that geometrical figure as a basis. If a basic shape like the cylinder is fairly easy to make, a trunk is even easier to paint or draw, because it is irregular whereas the cylinder isn't. After you have outlined the shape of the trunk, it is important to identify the darkest and the brightest areas. The deepest areas of dark are drawn and stained where the shadow falls. Dark areas are traced on the trunk and blurred over onto the brighter part.

FROM VOLUME TO TEXTURE

Over the tonal base just described, begin to work on the texture of the trunk. Texture can vary from tree to tree. In this example we show how to treat a particular tree, but we advise you to study every kind of bark. With small strokes, and following the volume of the trunk already picked out, build up the structure of the bark. It is important to leave the brighter parts standing out on the shaded side as evidence of the volume of that area. The brush-strokes tend to the vertical, although, as you can see, the shape of the trunk and its outline is followed faithfully, dictating the direction of the strokes.

CRAYON: IMPORTANCE OF THE STROKE AND OF THE CRAYON

Crayon is one of the best artistic techniques for drawing trees, although you need to take certain precautions. As it is a dry medium, the surface you are drawing on becomes very important, because it shows through in the stroke. In the following exercises, we will practice drawing trees with papers of different grains – medium, fine and coarse; in that way we will be able to see how the strokes comes out in each case.

A tree on medium-grain paper

Medium-grain paper is probably one of the most commonly used by devotees of both drawing and

painting. The exercise consists in drawing a simple tree; with this type of grain you can make any stroke, as it permits any kind of line without loss of the texture or grain of the paper. By pressing a little with the crayon, you can obtain a compact mark which covers the surface completely.

A tree on fine-grain paper

Fine-grain paper makes possible a line or stain showing no texture at all. There are many simple types of paper with a surface that presents no texture, so you need to be careful when choosing them, for it is not possible to use just any paper. The most suitable papers for painting trees with the quality of stroke we are looking for are those with a slightly rough surface, on which the crayon scrapes a little. Both blending effects and direct strokes can be made with the same techniques that have been developed in the first exercise of this unit, though of course varying each tone and each color.

A tree on coarse-grain paper

In this case a special water-color paper has been chosen with a very marked grain. In painting a tree on this type of paper, you need to bear in mind that the grain acquires a fundamental importance in forming the texture. When you pass the crayon over a coarse-grain surface, the stroke (without pressing too hard) adapts itself to the roughness of the support. As you can see in the example, the areas which must remain textured are maintained without pressing too hard; by contrast the denser ones cover the pores or grain of the paper.

How Van Gogh used to paint

We offer the beginner an analysis exercise on a work of Van Gogh, the picture The Flowering Pink Peach-Tree whose reproduction we have just seen a page back.

The process followed by this artist of genius in his work always starts out from a simple structure, which he enriches by applying successive coats of color. The intention of the brush-stroke is very important in Van Gogh's pictures. In reproducing it, it is important to study carefully how the colors are impasted over each other on the canvas.

You need to bear in mind that usually the new brush-strokes drag with them a little of the colors below.

The composition is simple, the tree stands a little off-center, and its volume has a rhomboid form.

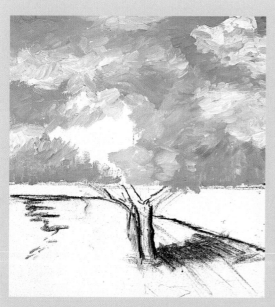

First, paint the area of the sky, thus staining the background to the flowered branches of the peach-tree.

Paint the ground and the fence, thus coloring the whole surface of the picture; now all the areas are defined.

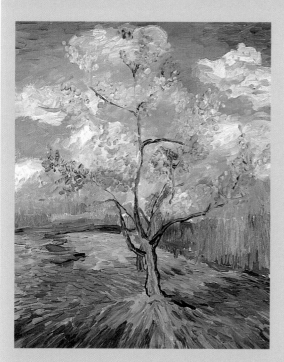

The colors for the pinks of the branches are crimson, orange, ocher, Naples yellow and white. The brush-strokes are short, without being reduced to dots. The central area of the tree is painted with orangish tones; and the right with red toned down with Naples yellow and white. The trunk is painted with blue and pumpkin tones.

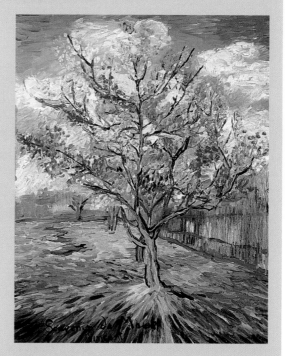

The last brush-strokes of the picture are now applied to the crown of the peach-tree. These strokes are numerous and steadily purer in color; even some pure reds and crimsons are painted which contrast with the almost whitened colors seen in the background of the composition.

3 Seascapes

Seascape is one of the most enthralling specialties of landscape-painting. It is true that many people who like to paint do not have the sea near by, but that doesn't need to be an obstacle; you will always have photographs or pictures which you can take as models.

Calm sea

This unit aims at developing the seascape genre paying special attention to the whole range of possibilities it can offer. Seascape-painting can be very complex, but we have opted here to tackle simple notions which can be guaranteed not to hamper the beginner's apprenticeship. The pictorial technique that will be employed in the following pages is water-color, which is perfectly adapted to seascape-painting.

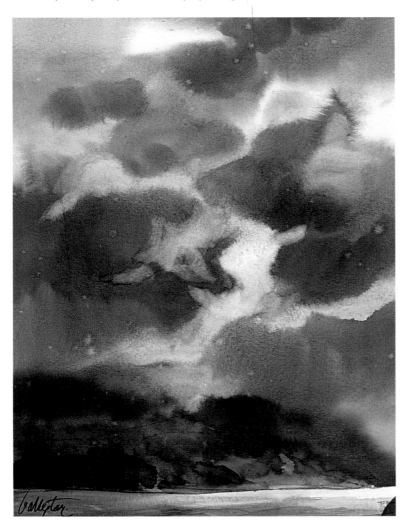

As you will be able to see in the examples that follow, these first seascape subjects are quite simple. The sea is presented in calm and there no difficulties beyond the natural ones of the technique you are working with.

THE LINE OF THE HORIZON

In all types of landscape, the line of the horizon places the viewer before the scene, at the same time giving a breadth which is determined by the point of view. To understand the importance of this effect, you only need to make a simple experiment:

- Stand on a high place and look at the horizon. The area of landscape falling below your line of sight may be extensive, but if you look down instead of looking at the horizon, the sky can seem to disappear completely from view.

- Stand somewhere low down, with no rises in the ground, and look at the horizon. The sky seems to enlarge itself before the viewer's sight; furthermore, if you raise your eyes, the line of the horizon can descend until it disappears. In seascape-painting, the primary importance of the view lies in

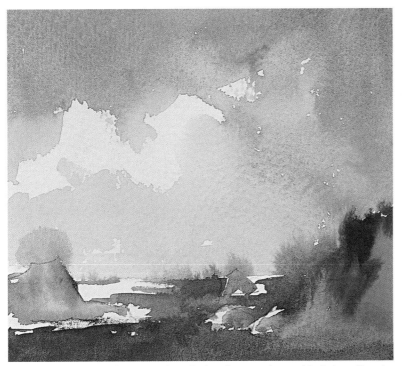

In seascape-painting, colors are as important as the correct use of technique. The sky, which is not always blue, is reflected in the sea, on which appear variations in tone, reflections and waves of movement which diminish visually with the distance from the viewer.

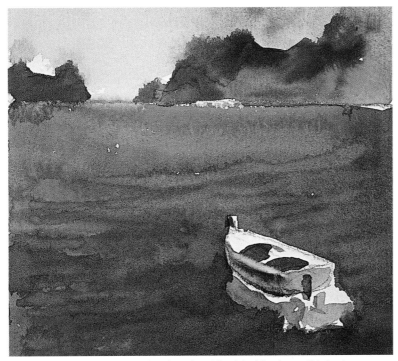

The horizon has been raised higher than the mid-point of the frame; this landscape allows the foreground to be shown in detail. The point of view has been raised.

the relation established between the area allotted to the sky and the area allotted to the sea.

THE IMPORTANCE OF THE HORIZON IN THE FRAME

Imagine in front of you a little black frame through which the landscape can be seen. Every time you select a landscape you are framing an area like that; it is like taking a photograph: when you look through the viewfinder you choose a particular framework. The horizontal references of the area framed serve to situate the line of the horizon in the rectangle. If you elevate the little frame or the camera viewfinder without changing position, the horizon is lowered; if you lower the angle of the viewfinder, the horizon is raised within the frame.

The observer's point of view is also very important in framing. The experience just described will not have the same result if done from a considerable height as if it is done from ground level. Look at the second sketch above: the seascape has been depicted from a fairly high point of view. The line of the horizon has been placed fairly high within the frame, which means we are looking at the view with our head slightly lowered; in this case we can see the boat below.

SKY AND SEA

LIn seascape-painting, colors are as important as the correct use of technique. The sky, which is not always blue, is reflected in the sea, on which appear variations in tone, reflections and waves of movement which diminish visually with the distance from the viewer.

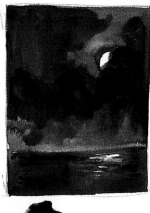

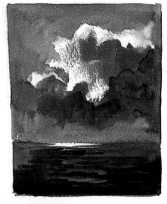

The background color of the paper is white, but tinging it lightly with yellow gives a great luminosity in depicting a bright day. Similarly the reflection of the sky can be seen also in the water.

In a nocturnal seascape, the reflections are shown decreasing in size from the horizon.

With a stormy sky, the color of the water is noticeably darkened; notice the difference in tones visible on the surface of the sea.
Pure white reflections are important to strengthen contrasts.

THE LUMINOUS SKY

The state of the sky is primary in painting the sea. When the sky is blue and bright, it is reflected in the sea as in a mirror, with the gentle undulations altering the reflections; these can be depicted with horizontal strokes in the distance, becoming wavier as the plane comes nearer to the viewer.

The brightness we give to the sky must be similar to the sea's, although the water always reflects light dulled down; i.e. the color of the sea always needs to be a little darker than the bright reflections it produces. When you paint the sky, in this case in watercolor, the yellowish tones applied to create the atmosphere of the clouds are also represented in the first coat of color used for the water. The later applications of color on the water are superimposed on the tones which serve as a base to create the dark tones of the sea.

A STORMY SEA

When the sky is overcast, the brightness of the seascape declines notably, except in areas where some ray of sun may filter through. The areas of greatest luminosity in a seascape with a very dark sky are translated into bright trails, very localized areas of light which can be represented with a pure white to heighten the effect of contrast. As the sea always reflects the sky's color rather darker, its initial depiction needs to be made with gray tones like the sky's; then, over this tone, the deeper, darker shades are painted.

A NOCTURNAL SEASCAPE

With extreme conditions of light, such as night, the seascape may acquire suggestions very rich in contrasts; of course in this case the tones are of one color only, and the transition between them needs to be very gentle. Placing the points of light correctly is important, as they establish obvious visual references such as, for example, the moon and its reflections on the sea. The reflections of the points of light are done very easily, brushing with the paint and leaving white areas alternating with the strokes.

BORDERS WITH THE LAND

It is easy to establish the difference between the line of the horizon and the sea, especially when there are no planes to interrupt the viewer's sight; but such an elementary composition

A surprising effect

Mist is one of the most subtle and beautiful effects to create. First, you dampen the whole paper with a yellowish wash; the line of the horizon is drawn with a blue brush-stroke which melds into the background.

The light effects achieved earlier can be represented in any technique, simply by replacing the white background of the paper with opaque white paint. Nevertheless, water-color has a language of its own, which cannot be translated by any other pictorial technique. Water-color's working on damp in combination with dry brush-strokes allows the creation of inimitable atmospheres, like the one shown here. This simple exercise consists in the depiction of a seascape with mist, a phenomenon which offers a greater kind of subtlety.

The sea, as can be seen, is wholly covered with the mist; it is not really painted but insinuated with a few points of reference, which make the viewer suppose that the water is there. The only trick that requires a little practice is simply waiting for the first coats of wash to dry.

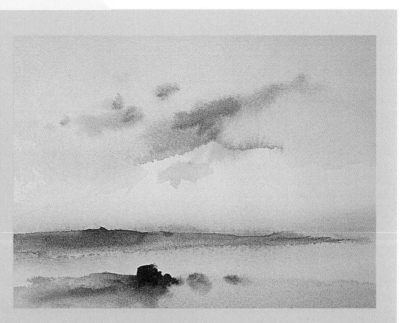

The high points that rise above the mist are executed by combining a very dry brush-stroke over an almost damp background.

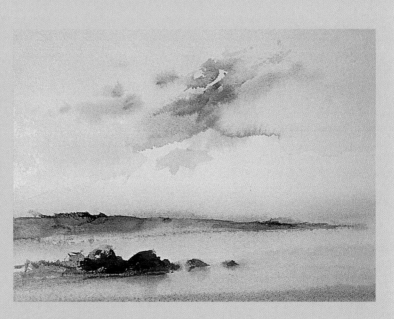

In the foreground, a sienna-colored brush-stroke is made, which is then blended into the background with horizontal strokes.

does not always need to be used. Often the artist will seek more daring compositions, in which different planes are established. Each plane will be a fragment of terrain that marks the distance from the place where the viewer stands to the line of the horizon.

FROM THE DRAWING TO THE FIRST COLOR

When no other elements exist than the calm water and the sea, the preliminary sketch shows no more than the line of the horizon, and at most the shape of the clouds. But if you decide to include some accidental feature, like islets or rocks, it is important to situate them in the frame so as to take them into account when painting. The drawing again becomes an essential preliminary before you start staining in color. Each section of rocks or mountains is situated in a plane which has a border with the sea. The further away that plane is, the closer to the horizon is the line which defines its base on the sea .

The first color to be painted is that of the sky, for that is the basis from which the colors of the sea will be done. If we want to paint land emerging above the line of the horizon, the horizontality of this line needs to be well established. However, as the land will be painted in dark colors, it does not matter if the blue of the sky penetrates into the area intended for it. In fact it is better if the color of the sky overlaps into that area, for that way it is easier for the painting of the land to stand against the background of the sky.

SHINING EFFECTS ON SEA-WAVES

In the distance, reflections are not too important, and they are often translated into a few dark strokes on a blue background. On the closer planes, however, reflections acquire a primary importance. A reflection painted in water-color is no more than a reserved area where we can clearly see the

Simplicity

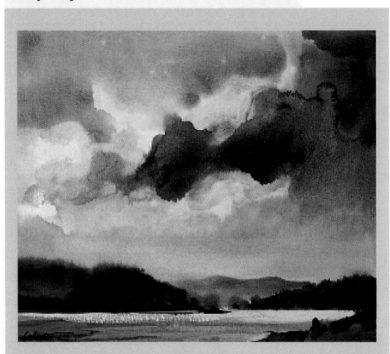

Looking at this work by **Vicenç Ballestar** (1929),The Storm, from a private collection, one can see that a seascape does not need to be a work of detail. The artist has achieved it by means of a few stains, simply observing the view and interpreting, through a combination of damp and dry touches, the sky (whose clouds have been defined with a broad dark wash), the land (whose main interest lies in the cut-off with the sea) and the glitter of the water (achieved by painting the sea once the background was dry).

background of the paper between the brush-strokes. The reflections are waves; these need to go with the plane of the water. Let us imagine for example that we are looking at the water from directly above.

If you drop an object, concentric circular waves are produced. If you observe this effect from a little distance, the waves are not seen as circular but in the shape of an ellipse, narrower and narrower the further away they are from the viewer. When reflections arise around some rocks they won't have a concentric shape, but their shape must still follow the plane of the water.

PLANES

Another important point in painting any landscape, and specifically a seascape, is to paint each plane of depth in the picture with a different tone according to its distance from the viewer. The planes showing the greatest contrast are those of the foreground, although this will also depend on the position of the sun relative to the earth.

In drawing the preliminary sketch, you need to situate the line of the horizon first; with this as a basis, you can situate any rocky outcrops.

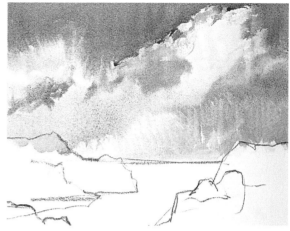

Paint the sky, which outlines the clouds. The middle tones of the clouds, being lighter than those of the rocks, may overlap into the area occupied by the rocks.

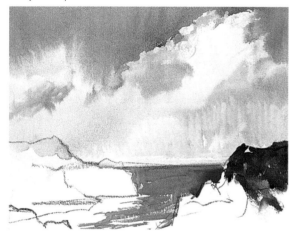

The water, represented with a strong blue, stains the background; in the foreground it turns into separates strokes which indicate the reflections.

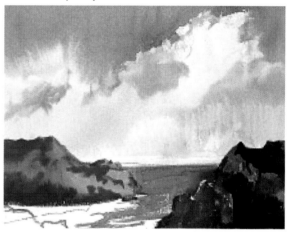

With rich and varied colors you establish a clear difference of tones between the boundaries of the rocky areas.

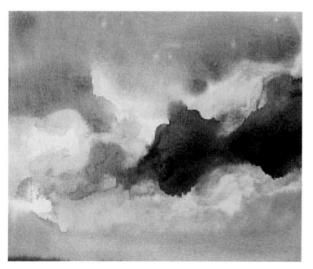

Be careful to maintain a difference of tones between planes of depth, and learn to establish the areas of brightness in the water.

One way or another you need to achieve a difference of tones and contrasts to ensure an effect of depth. Once the principal tones of each plane have been settled it is important to do the same with the reflection of the colors. In this example you can see how the reflections have been painted with earth-colored tones and with wavy strokes. To avoid the reflections mixing with the background color, you need to make sure that the background is completely dry.

THE SHORE AND TREES

A seascape may have as its borders the sea or a variety of accidental features. In the first case there is no border to the water; in the second, the sea is bordered by rocks, but their shape marks a sharp break with the sea's surface and is easily depicted.
The composition becomes more complicated when a sandy shore and some trees are introduced; now the borders do not make a sharp break.

CREATING ATMOSPHERE

In water-color, the atmosphere depends on the basic color of the paper. To apply an atmospheric effect, you first need to apply a coat of paint to the surface of the paper. Here a very luminous yellow is used, which is spread over the whole surface with quick even strokes. Before you begin to paint, this wash needs to be fully dried. With this color as a base, all the tones will be conditioned by the background of the paper, and the most luminous points will be the yellowish background itself. Once the surface has dried, the sky is painted. The shape of the clouds is outlined with blue. Take care over the work on the surface of the water, which is begun with blue, leaving the spaces of reflections unpainted. To depict the middle distance, paint again in yellow, not too...damp but enough for the tones to

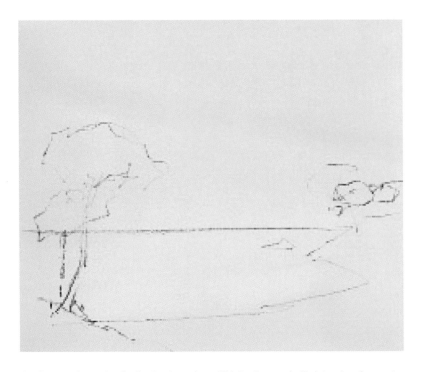

A yellow wash creates the basic atmosphere. This background will determine the most luminous points.

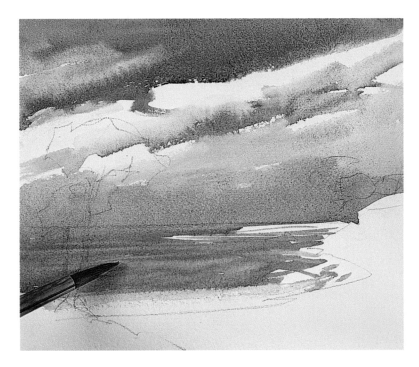

Paint the sky and the blue of the sea except for the reflections, then paint once more in yellow with very little paint.

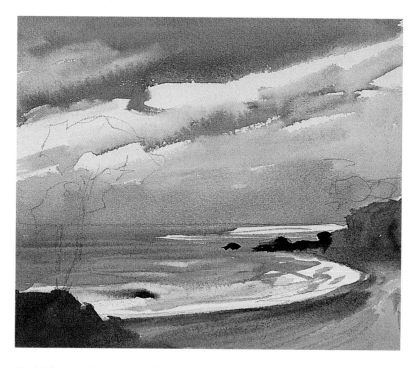

The brightest points are painted first, before the trees; next paint the shoreline.

mix. To retain the whites, brush over repeatedly with a clean dry brush so as to absorb part of the color and create brush-strokes, slightly swollen by the damp.

THE BEACH AND TREES

Before you paint the beach, the surface must be quite dry, so as not to stain the color of the sea with the dark ocher of the earth. The shape of the beach is defined at the line of the shore; between the shoreline and its meeting with the sea, leave a thin separation, to let the color of the background breathe between the water and the land.

The way the brush is applied defines the land in the area of the shore. The brush-stroke is long and curving, and the tone fairly light; at the ends, denser and darker tones are used. The trees are painted once the surface is dry; in that way they can be superimposed on the landscape and worked over without the danger of the color running onto the background. First, paint the tree-tops in lighter tones; then put in the dark areas in blue and green. The darker contrasts of the land are painted last.

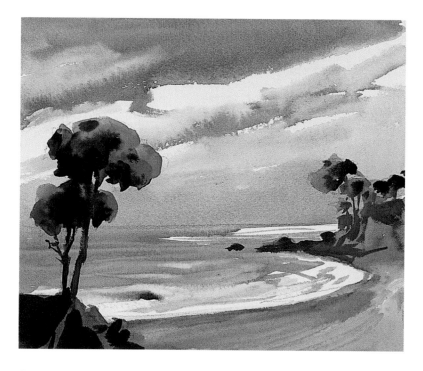

Once the background is dry, paint the trees in darker tones.

4 Landscapes in gouache

One of the most interesting techniques when you are learning to master painting and drawing is gouache, a process peculiar to water-color using just one color, though in all its tonal variants.

Applying the color

Gouache – which is based on the use of a single color in all its tonal range – was there in art long before water-color existed as an artistic technique, for artists, before painting a picture, used to make preparatory sketches on paper in a single color.

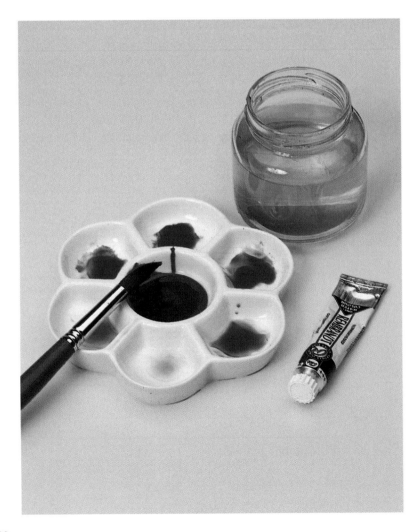

This is a technique that straddles between drawing and painting, and its practice enables the beginner to advance in his mastery of water-color, since after all gouache is no more than water-color made in just one color. This enables you to familiarize yourself with the medium before you start handling several colors together.

MATERIALS REQUIRED

Painting in water-color only requires the paints, paper, water, palette and brush; but doing a gouache calls for even fewer tools, since by using just one color the basic equipment can even do without the box of colors. In fact all you need is:

- One water-color paint
- Paint-brush
- Palette
- A jar of water
- Paper

The economy in materials permitted by gouache leads to its being used by painters when traveling.

THE BRUSH

To make a gouache you need only a

Paint-brushes

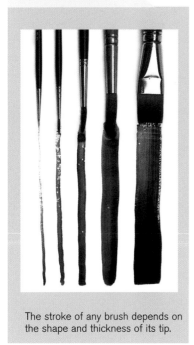

The stroke of any brush depends on the shape and thickness of its tip.

It is worth trying out the possibilities of each brush with a tone of gouache to see what sort of stroke it will produce.

TYPES OF BRUSH

Although only one brush is needed to do a gouache, every painter usually has a complete set of them in his studio.

All brushes have a number stamped on the handle, allowing the size to be cataloged and standardized. The finest are classified 00000 (5/0), and the number of zeroes is reduced as the size of the tip increases until ordinary numbering is reached, which goes from 1 to 50; the last belongs to the thickest brushes on the market.

The lower the numbering of a brush is, the higher its quality needs to be to conserve its suppleness and its tip.

THE TECHNIQUE OF GOUACHE

In water-color, if you gradually add more water to a particular color, you will get lighter and lighter tones. This means that you can obtain a great variety and richness of tones from a single color.

Gouache consists precisely in that: progressively mixing a color with water, each time obtaining different tones with which the picture is painted. Needless to say, when you are using just one color the search for lighter or darker tones is much simpler than when you work with a great variety of colors.

But gouache also allows you to do work of a linear type, like charcoal drawings. In this case just one mixture is used with little water and without variations of tone.

brush, which ought to be of marten or ichneumon hair, to have a high capacity to absorb the color and permit a perfect control of the brush-stroke. Manufacturing a good-quality brush is craftsman's work, since the hairs are chosen, put together and fixed by hand.

THE BRUSH TIP

The tip of the brush needs to be supple, allowing the stroke to bend one way or the other at the will of the artist. In fact the brush-stroke is entirely dependent on it; thus, a round brush ending in a point permits a fine stroke with high-quality point-work, while a round blunt one makes a heavy, thick stroke, with no point. The shape of the brush-tip is determined by the way the hairs are set in the collar.

DRYING THE BRUSH

After each painting session, the brushes need to be washed carefully, because a wet tip becomes soft, and if it is not dried its shape may get deformed.

To dry the tip, rub it with a soft cloth or absorbent paper following the direction of the hairs, taking care not to twist them to avoid deforming the root of the tip. You only need to get rid of the excess water and restore the original shape with your fingertips. If they are going to be put away for a long time, the brushes ought to be completely dry, so that they don't get moldy or start to rot.

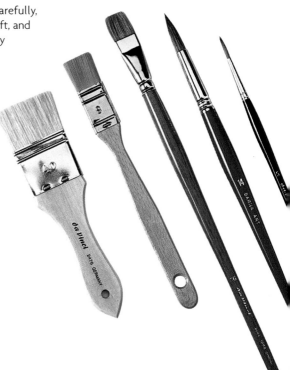

TONING DOWN

To tone a color down, you need to take a sheet of paper and prepare a color on the palette. Then wet the brush in water and dampen the paint; with that you obtain a relatively opaque color, which is the thickest obtainable in this process of toning. Next, draw a long stroke on the paper with the color obtained; then immediately wet the brush again in clean water, dab it to get rid of excess water and apply it over the brush-stroke, dragging part of the color with it. As the new stroke adds no color but only dampness, the result is to tone the color down.

If you want to tone down further, just dampen the brush again in water and draw out the paint as many times as necessary, until you achieve the tonal variety you are after.

Toning on a damp background. You can also tone a color down on a dampened surface. In this case, just stretch out the paint and reduce the color with a clean brush in the areas which need to be brighter.

CREATING A TONAL SCALE

As already observed, in water-color toning down is done with water, and this means that when the paint is applied to the paper, tonal scales can be achieved. The tonal scale is simply the application of color to the paper at different stages of its tone. Obtaining a tonal scale is not difficult, but it requires a number of trials to be done on the paper. For this, put some color from the tube onto the palette and paint the color closest to the pure color; next, add a little water with the brush, and you thus get a second tone, rather lighter; go on adding water to obtain the next tone, repeating until you have completed the scale.

Once you have the scale, you need to bear in mind that when you paint a picture the order in which you paint a tonal scale of a single color is always from light to dark: first paint the brighter tones on the surface, and once they are dry you can apply darker tones beside the bright areas.

The first step in toning down is to draw a dark brush-stroke on the paper.

Then wet the brush in clean water and stretch out the previous brush-stroke.

Repeat the process as often as necessary till you have the tone you want.

THE TONE AND THE PAPER

Painting in water-color is like drawing as far as the search for tones is concerned, but achieving these is not as easy as when done with a pencil or charcoal, amongst other things because the capacity of absorption of water-color is different on the different types of paper used by artists. For water-color to have the tones you want, you need first to make tests of the tone on sheets of paper identical to those you are going to use for your final work. In that way you will find out how absorbent the paper is, how long it takes to dry, and the visual effect produced by each tone.

TONAL SCALE
IN A LANDSCAPE

The following is a simple example to help you to understand how tonal scale is applied in gouache. It involves painting a landscape, because this, in contrast to still life, is always a free and spontaneous kind of work, which doesn't require following unduly complex models of work or highly defined contours..

First of all, paint the area of the sky with an even wash of almost transparent blue. This is the first tone and therefore the basis for the remainder, which will always be darker.

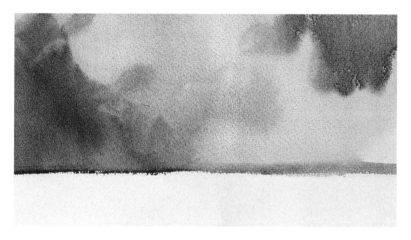

Wait for the first wash to dry completely, and then paint over it another, rather darker wash. The background tone is now bordered by this new color.

Once the previous coat is complete, wait for it to dry completely, then paint with another, much darker tone some of the details of the sky and the objects in the space below.

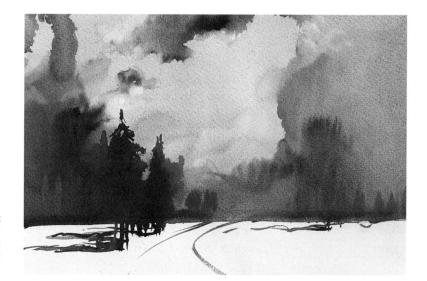

31

5 Painting reflections

One of the commonest challenges for the landscape artist is depicting reflections. Reflections are formed on surfaces whose material makes them capable of reflecting everything around them. This means the water of ponds, lakes or pools.

Bodies reflected in the water

There is one problem which beginners in painting do not take into account. One tends to think that reflections are produced the same on both sides of the dividing line between reality and reflection. But they aren't; the duplication is not a precise one. The reflections produced on a water surface may be many and very varied, for they depend on various factors: the movement of the water, the amount of light or the angle of inclination to the surface.

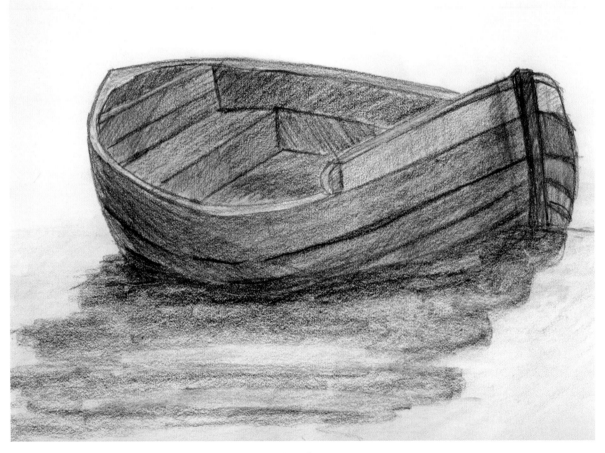

If the water is in movement, the waves break up and lengthen the reflection.

The reflection of an object, then, depends on its angle of inclination, on its direction. If it is tilted towards the viewer, the reflection will be lengthened, appearing with a more stylized silhouette. The greater the inclination, the greater this lengthening will be, though there is a point past which it will disappear. This happens because the reflection duplicates the same direction and angle as the object it belongs to.

If the object is tilted away from the viewer, the reflection will be short. If the object is vertical, the reflection will be exactly as long as the object.

One other point we should not forget is as follows: if the surface of the water is not calm, the reflection will break up. The nearer we are to the object, the larger and more broken will its reflection appear. When we move away from the object and its reflection, we can observe that the breaks in the water become smaller and therefore appear as a single mass beside the object.

As already remarked, reflections depend on the light. You get a very clear reflection when the sun or the source of light are shining in front of you. As the part reflected is in shadow, the reflection is seen more clearly; this happens, for example, with boat hulls painted in black or in a dark color. The opposite happens when the object is illuminated: you get a more subtle reflection.

To continue with reflections in the water, there is one subject which is very frequently depicted by artists because of its compositional beauty – bridges. Bridges are many and varied because of man's constructive richness throughout history all over the world. One fact can be realized at a glance: the reflection of a bridge shows its underside, making the reflection larger than the bridge itself.

The reflection

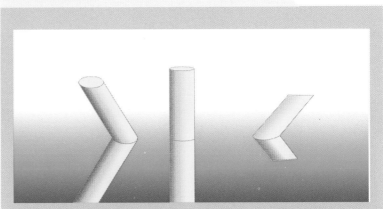

The reflection of an object tilted towards the viewer increases its length in comparison with the original. If the object is perpendicular to the reflecting surface, the reflection is the same length as the model. If the object is tilted away from the viewer, its reflection will be shorter.

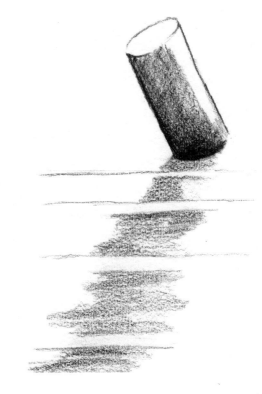

If the water is in movement, the waves break up and lengthen the reflection.

This is true both in parallel and in oblique perspective. The reflections in a mirror occur differently, as normally the mirror duplicates all the objects in front of it. In parallel perspective, objects are inverted sideways, i.e. the right appears on the left and vice versa., but up remains up and down remains down.

Distance also remains the same. This means that if we place a box in front of a mirror the distance between the box and the mirror will be the same as that within the mirror.

SEA MOTIFS
AND RIVER LANDSCAPES

Sea motifs are usually very suitable for painting with techniques such as water-color, as this enables the artist to express the lightness and the transparency that these subjects usually require.

In painting sea motifs, perspective is shown above all in the treatment of reflections. You need to bear in mind that these have their own rules, and also follow the rules of perspective of the objects they reflect. Calculating a reflection is not too complex if you follow the instructions of the chapter devoted to them, but when you put it into practice you need to pay attention to other factors, such as tone and intensity of color.

Natural landscapes are an inexhaustible source of examples of reflections on the water. Lakes and ponds often show on their surfaces the reflected shapes of the objects around them. Here we have taken the example of a lake with trees.

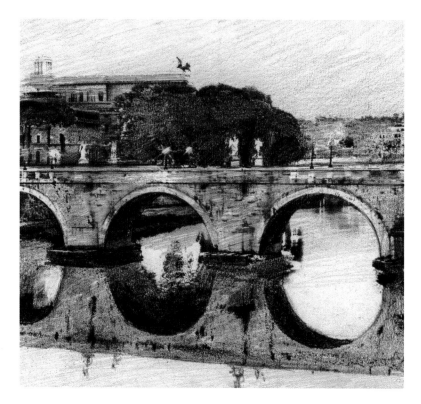

This bridge depicted in oblique perspective has a reflection larger than itself, because its underside is reflected.

Landscape allows a large variety of interpretations, so even if it is done in a realistic style it is feasible to begin by staining in the shapes in a very loose and spontaneous way. In this case we need to seek the dark areas and later outline the brighter ones of the upper part of the wood.

Start by painting the trees with oxide green and yellow; mix both colors a little with black to get the different tones that can be seen in this image.

Paint the undergrowth fully and begin to paint the reflections of the water with sienna. In the area nearest to the vegetation the brush-strokes are long and horizontal, while in the reflection further away the strokes are shorter and vertical.

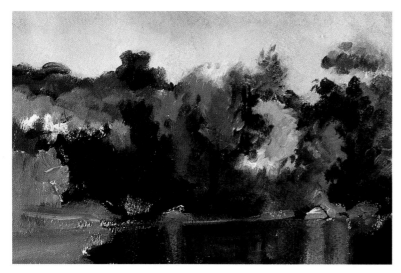

After painting the trees on the right, apply a dark coating which serves to shade their tones.

The work centers on the depiction of the reflections on the water: Notice how the different planes of color are achieved, in particular the brightest reflections, painted with small, thick horizontal strokes. The area of the water is done with different treatments: transparency and blending of tones to make the reflections and dark transparencies, and opaque brush-strokes to paint the reflection of the sky in the foreground. In the area of reflections on the left, a great mass of luminous color is painted.

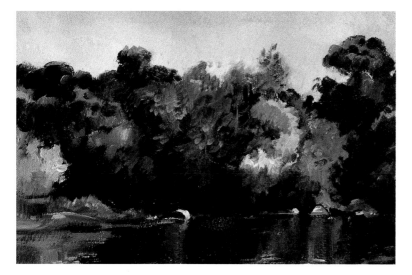

Paint with slightly transparent dark sienna over the dark area of the reflection on the left. In the brighter part of that area paint with light green, applying it with vertical strokes.

The blues representing reflections are painted much brighter. With this contribution of light the whole landscape gains in contrast.

As can be seen, the final stage is to paint the more illuminated area of the water, where the blue of the sky is reflected with short horizontal strokes.

Reflections: tone and chromatic intensity

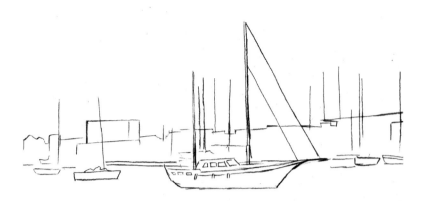

First outline the general shapes of the boats, and lightly insinuate the buildings in the background. As can be seen, the horizontals and verticals predominate in this composition, which gives it a great sensation of stability. In the pencil drawing it is not necessary to put in the reflections, as these are simple enough to be made directly with the brush, thus avoiding the pencil marks later showing through under the water-color.

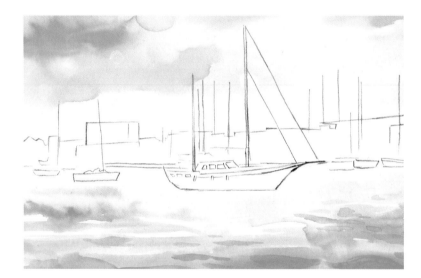

The sea is treated in a similar way to the sky, except that here a darker tone of blue has been applied. The shape of the waves has been expressed through slightly wavy brush-strokes letting the shine of the paper show through in some places. The bottom part of the composition has greater tonal contrast, because it is the one closest to the viewer.

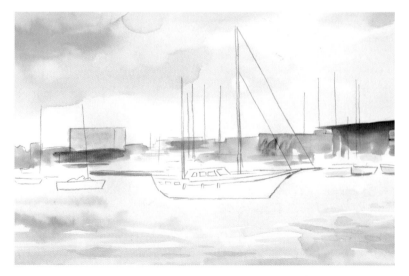

In the buildings in the background, light brown and greenish variations have been applied in a very light way. We do not want these to have too much contrast of color or too much detail, because they are situated in the most distant part of the composition. It would also be counterproductive because it would take away importance from the water, which by its nature always shows more subtle contrasts.

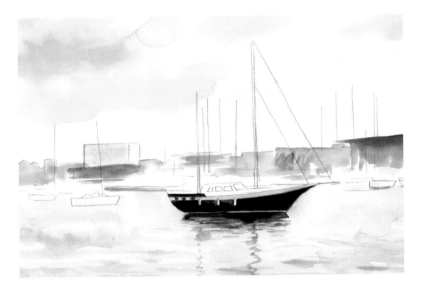

In the buildings in the background, light brown and greenish variations have been applied in a very light way. We do not want these to have too much contrast of color or too much detail, because they are situated in the most distant part of the composition. It would also be counterproductive because it would take away importance from the water, which by its nature always shows more subtle contrasts.

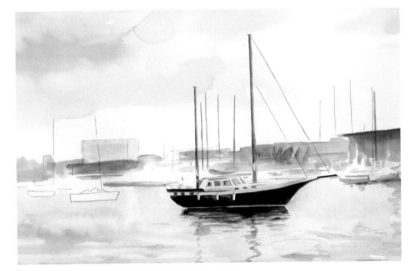

The boat in the center is given greater detail and the background boats are drawn simply, reducing the detail as the distance increases. The depiction of the waves is intensified in the area of the foreground.

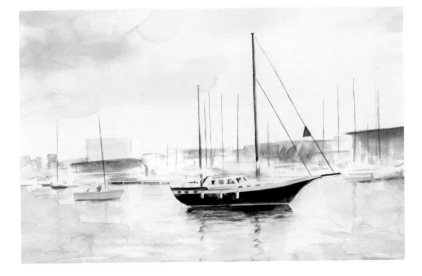

The remainder of the boats are drawn in light tones and their respective reflections are placed in the water just as was done with the first. The color of the reflections also needs to get lighter the further away they are. Besides the reflection of the masts of the boats, the buildings also reflect their own colors in the water, which are cast below, and although owing to the distance their outlines are not delineated on the sea's surface, their brown tones also show lightly in some places.

6 Perspective and landscape

Perspective enables an illusion of reality to be created on a two-dimensional surface. The perspective employed on paper is called linear perspective and is based on natural perspective.

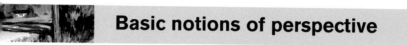

Basic notions of perspective

When we look around us we see clearly that objects appear smaller the further away they are. We also see that two parallel lines converge in the distance, coming together on the horizon, as in the case of a railway line. The main reason for this is that the angle the eye needs to take in to grasp an object becomes smaller the further away it is.

For the same reason, the angle taken in by the eye when it looks at a railway line narrows with the distance. The method of perspective sets out to find the rules for calculating these effects.

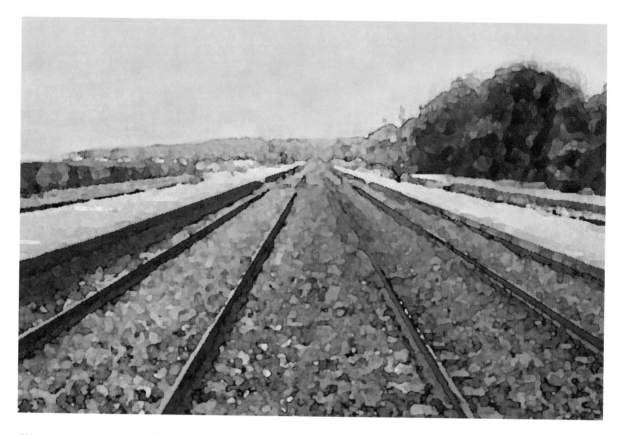

Although we know that railway lines are parallel, when we look at them they seem to come together at the horizon. This is one of the principal effects in perspective.

Basic concepts

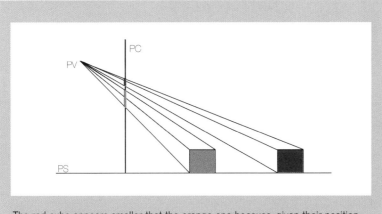

The red cube appears smaller that the orange one because, given their position, the visual angle necessary to take it in is smaller. This is the reason why objects appear to get smaller with distance.

PARALLEL PERSPECTIVE

Depending on the number of vanishing points you use in drawing a perspective, you get three well-differentiated types of representation of space in depth.

The first type of perspective treated here is parallel perspective. Here we have the same concept of central perspective discussed in the chapter on history referring to the Renaissance advances in perspective.

Parallel perspective is used when we want to depict one or more objects whose front surface is parallel to the plane of the picture, and the other surfaces at right angles to it. This type of perspective is characterized by having only one vanishing-point. That point is situated in the spot where the line of the horizon and the visual center-line cross. The visual center-line is the one, of all those running from the viewer's eye to the object, which is exactly perpendicular to the plane of the picture.

Thus, in the figure, the vanishing-point and the point of sight coincide. On this vanishing-point converge all the lines perpendicular to the plane of the picture, and it is therefore the center of reference of most of the lines that are drawn when this type of perspective is depicted.

Parallel perspective, with a single vanishing-point, becomes more evident in cases like the example of a landscape with trees described in these pages, where there are a number of objects of the same size aligned in depth.

The progressive diminution in size of the trees creates the effect of perspective in a very simple way.

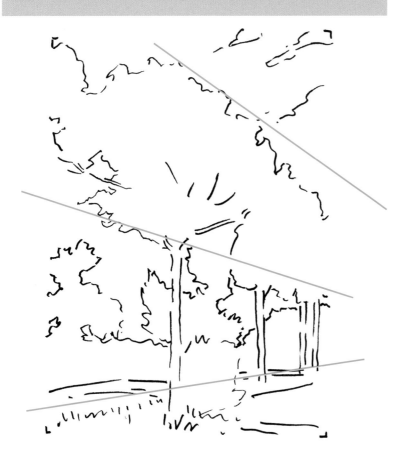

First draw the outline in charcoal. In this first sketch only the main shapes are inserted.

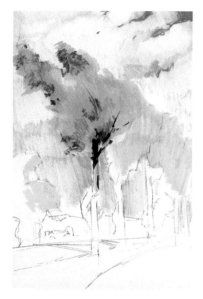

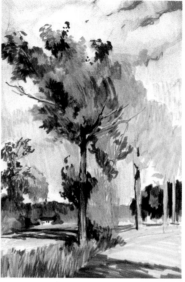

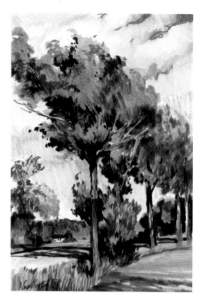

Start by applying color to both the trees and the background. The color of the sky is made light and with little saturation, to suggest distance.

On the trees in the foreground apply the color more darkly to heighten the effect of depth. The grass at the bottom is also treated in more detail.

The shadows cast by the trees on the road help to situate them. The shadow on the ground marks the foreground of the earth.

We can see that the vanishing-point of this perspective lies to the right, off the picture.

HORIZON

The concept of a horizon in drawing is the same as we obtain from looking at the sea. The line of the horizon closes the view of the onlooker in the far distance. Very often this line is imaginary and we need to situate it at eye-level, bearing in mind another concept, the point of view.

The point of view is the center of the angle made by the viewer's visual field directly in front of him; it means the height at which the observer's eyes are, and we can therefore say that the line of the horizon is always in front of us, before the level of our eyes.

In drawing, the vanishing-points are always on the line of the horizon.

HEIGHTS OF THE HORIZON

As we have seen, the line of the horizon has to be situated at the level of our eyes. Thus we can say that its height varies with the position of the viewer and also his angle of view. A low horizon implies a low point of view, and therefore the whole view is similar to what a small child might have.

Buildings and objects around us loom above us, so their proportion in regard to us will be exaggerated. This way of representing them is used especially when we want to give a monumental or gigantic appearance. On the other hand a high horizon line diminishes everything that lies within our visual field. If we want to depict a well-proportioned view, we will do best to place ourselves in a position where

our eyes remain on the horizon line at a medium or low position in relation to the buildings and the objects we wish to study.

DETERMINING HEIGHT IN RELATION TO THE HORIZON

Another concept the artist needs to keep in mind is the way objects are situated in relation to the horizon line. An object placed near the horizon line is not the same as one at a distance from it.

The clearest example of this visual phenomenon is telegraph poles ranged along a road, for we can see that although they are all the same height they diminish in size as they

SKY

HORIZON LINE

SEA

BEACH

We find the best representation of the concept of the horizon in the natural horizon line, which we see when we look at the sea.

approach the horizon, i.e. get further from the viewer.

We see another example if we look at a ship on the horizon. We know that the ship is bigger than the boat moored on the beach, but its proximity to the horizon makes it visibly smaller.

Let us observe a city street. The receding lines converge on a single point (VP), which may be lateral, to right or left, or central.

In these cases the sidewalks and the lines of the house fronts converge on the vanishing-point, so that we can rapidly see that the buildings at the end of the street appear smaller by the effect of perspective. If they rose higher than the buildings closer to us, it would be because their real height is very much greater.

INVISIBLE HORIZON

When we are standing in a street that slopes, whether up or down, we need to speak of an invisible horizon. When the street slopes upward, the line of the horizon is below the point where the convergence lines of the buildings come together, while those of the sidewalks converge at a point on the

same vertical line as the vanishing-point but above it.

In the opposite case, i.e. when we are looking from an elevated point in the street, we can see the lines of the sidewalks converge at a point vertically below the vanishing-point of the buildings, which lies on the horizon line, now situated above.

Another case of an invisible horizon is found in upward views and in aerial perspective. If we look at an object well above our eyes (upward view), the line of the horizon falls outside our angle of vision; yet it still exists. All the lines that would seem horizontal if we looked at a building frontally (such as windows or cornices), converge in this type of perspective towards a horizon line which would lie outside the picture. The same happens if we look downward from a great height (aerial perspective).

EXPERIMENTING WITH THE HORIZON

Landscape is the best testing ground to experiment with the height of the horizon. Two landscape models will now be developed which will help us in practicing this subject.

In this case we have set the horizon very high. For that reason the sky has been reduced to a small blue fringe. That is because we have placed ourselves on the slope of a mountain looking up at its peak. We thus have a large space to show the different sectors which give depth to the picture. Given the rockiness of the landscape we will use layering paste.

A sunset is a magnificent opportunity to work on the sky, and therefore on the horizon. In this particular case, the line of the horizon is in a low position, so that we have a large amount of space for the treatment of the sky. To have placed the line of the horizon much higher would have greatly limited the leading feature of a sunset, which is the sky. We can observe that the model taken is a sunset in which the chromatic richness of the orange and reddish tones has a great evocative power.

We also apply layering paste on the hill seen in the distance, just up to where the background trees begin. The whole hill is painted with a tone of green mixed with white to give a feeling of depth. The greens applied in closer planes are purer than those in this area. When the hill is painted green, the layering paste is completely covered.

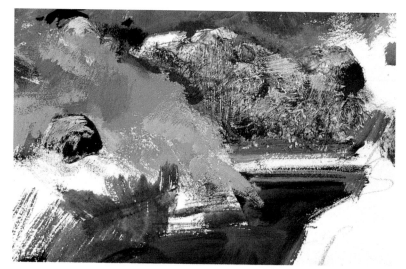

In the same way that the texture has been achieved on the distant hillside, the texturing of the rocks is begun with a dark gray color. Then, once it is dry, it is painted with a rather worn brush in a tone close to white, bringing out the rough texture of the rocks. The trees in the background are painted in very dark tones of green. In the brighter parts the green is mixed with yellow to convey the look of the drier grass. Where the grass is thicker, the green color is much darker.

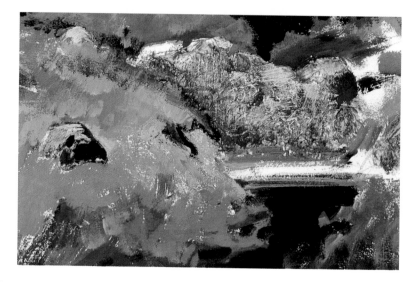

In this landscape it is very important to have a good range of greens to obtain a good effect of depth, also helped by the texture of the support. With a medium green, paint the light parts of the tree over the stones; these brush-strokes need to be short and well pasted in. The water under the stones is painted with a greenish tone obtained from orange ocher and green. As you can see, the foreground has greater contrast of color than the background, which has a greater chromatic harmony.

First paint a very watered-down violet color. Underneath, its complementary, and in the lower area another band of orange. With this combination of colors we can give the chromatic richness that this motif requires.

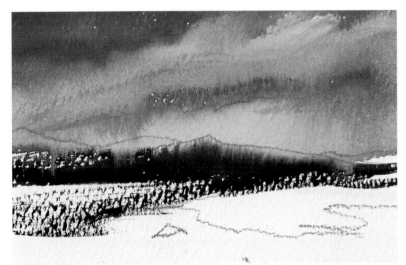

Over the oranges of the sky, paint with cadmium red. Lastly paint the ground with the points of light on the water.

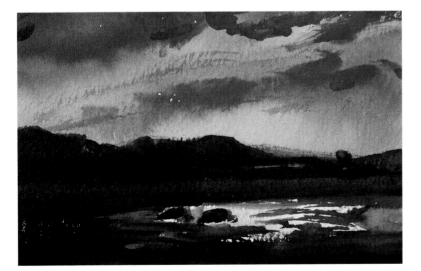

Over the orange paint with yellow ocher; the central stain is taken up by this color.

7 Depth in landscape

There are three basic colors: yellow, magenta and cyan blue. From the combination of these three colors come all the others. If we mix these colors two by two we obtain the secondary colors.

Depth through color

Green comes from the mixture of yellow and blue, red from the mixture of yellow and magenta, and violet from the mixture of blue and magenta. Complementary colors are those which share no color in their composition and they are therefore the ones which have most contrast between them. For example yellow and violet are complementary colors (as above, violet contains blue and magenta but not yellow).

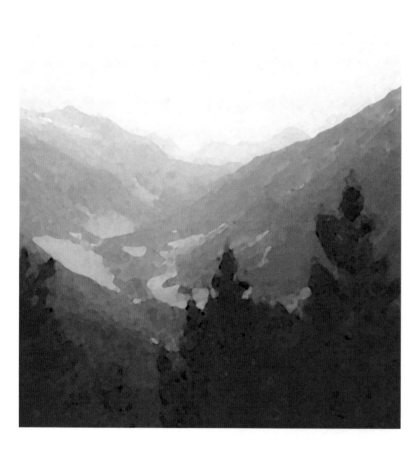

In the distance colors become colder (they tend towards blue), they become steadily grayer and lighter. The best place to see this effect is in mountain landscapes where the more distant landscapes fade into the white of the sky.

Following the same procedure of mixing two primary colors and opposing them to a third, we find that blue and red (the mixture of magenta and yellow) are complementary, and so are magenta and green (the mixture of blue and yellow). Applying this to the effects of depth, we can deduce that the use of colors with a lot of contrast between them (such as complementaries) is right for the foreground, while in the more distant areas we need to use more harmonizing combinations of colors .

Besides this, there are colors which, by their visual effect, are considered warm, like red and yellow, and others which are considered cold, like blue and violet. The warm colors give an impression of closeness, while the cold ones suggest distance. The foreground presents livelier, warmer and more contrasting colors and the background presents colder, grayer and less contrasting ones.

If we look at a landscape with mountains in the distance, we will notice that the further away these get the lighter and bluer their color becomes, with decreasing contrast to the color of the sky. This is one of the clearest

Harmonizing colors

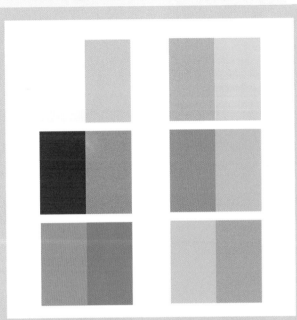

If we juxtapose harmonizing colors, like those shown in the illustration, we make the elements we are treating with these colors lose chromatic contrast and visually distance that area from the scene.

examples of the notions we have explained in this chapter. To represent the depth of a space, it is not always necessary to use explicitly the resources of linear perspective.

Often, when one is painting a natural landscape in which the accidents of the ground are arranged irregularly, there are few elements suitable for tracing a linear perspective that will suggest distancing sufficiently strongly.

It is in these cases that the resources of pictorial perspective, as we call it here, become more necessary. In this exercise in crayon, we will see how, besides the saturation and contrast of color, the line also has its own function in representing depth.

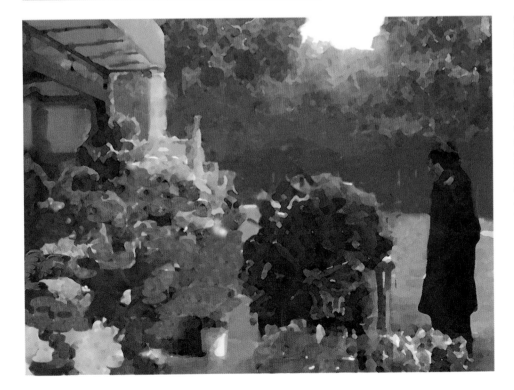

Very strong colors in the foreground help to promote the effect of depth. Pairs of complementary colors, like yellow and violet, create a strong contrast and bring closer the area where they lie. If the same saturation of color had been used in the trees in the background, the scene would have substantially lost the effect of perspective.

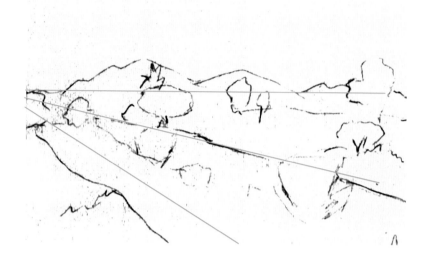

The initial drawing does not need to be done with great precision, since all its visible elements present irregular shapes which offer a wide margin of variation without ceasing to look realistic. Outline the main shapes, leaving minor details to be treated when you work in color. The path traced by the scene into the distance will help us to express depth in this work.

The first stain of color needs to be a gentle one. Apply the crayon without pressing too much so as not to leave marks; then tone down with a finger or some cotton wool. You thus create a base on which to add later details. In this first staining only warm colors such as yellow, red and an earth color have been used. Remember that it will always be easier to "cool down" a warm tone later than to reverse the process.

Continue applying the color of the sky as just explained. Avoid making too great a contrast between the sky and the mountains in the background, since, as mentioned before, strong contrasts tend to make the area they appear in seem nearer, and here we want the opposite. Also put in more details little by little on the ground, such as the bushes and hillsides, always keeping a view of the scene as a whole.

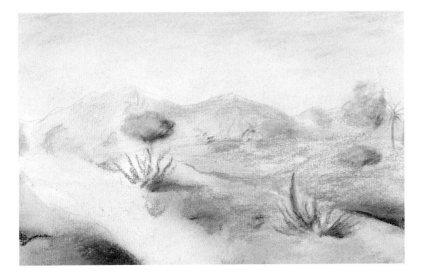

As you draw the different plants and cactuses on the ground, you need to treat them in a different way according to where they are placed. Leave the more distant ones vague, and define them more and more as they approach the foreground. As we can see, the bush on the left has been done with a green mixed with yellow very intensely, and very marked black strokes have also been added on top.

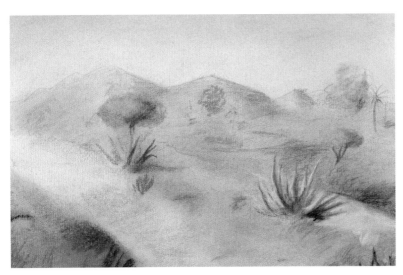

To make the foreground stand out, use warm colors at the bottom of the picture. The yellow of the ground becomes denser there and you can also apply some reddish strokes to the bush on the left. Also, the white strokes outlining the cactus on the right create a strong contrast with the shadow cast by its leaves.

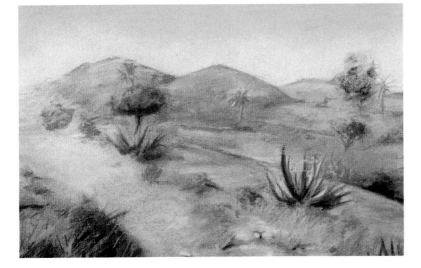

One of the advantages of crayon drawing is that it permits a good variety of treatments, which has been used here to express perspective. As already mentioned, the crayon line is also one more factor that can be used to suggest distance. While the sky and the mountains in the distance have been gently blurred with cotton wool, all the foreground elements have been drawn with very clear strokes. That is the way the stones, leaves and spikes have been drawn.

DEPTH
THROUGH THE USE OF LIGHT

One of the most influential elements for creating depth in a scene is light, through which the volume of bodies is perceived and expressed. The light in which we are observing an object has a great influence on how we see it.

In general, a direct light tends to emphasize details more because the shadows it casts are seen more clearly and bring out aspects of the object's surface. But if the light is too direct and the light and shade effect is exaggerated, the shadows can obscure a large part of the object.

This type of lighting gives an picture more expressiveness, but it loses in description and clarity. By contrast a diffused light, such as that of a rainy day, allows things to be seen very clearly, but with the softening of shadows the objects can lose volume and seem more monotonous.

The use of one type of light or another must be dictated by the kind of image we want to achieve and the feeling we want to convey with it.

As remarked before, a more direct light can make an image stand out; for that reason a quite effective device is to give more contrast of light to the foreground of a composition and leave the background in a more diffused light, blurring the outlines and lightening the shadows.

Another way of differentiating very clearly the different areas of the picture is to give them a different intensity of light, alternating shadow and light. For example, in a landscape you can leave the center of the composition (the central part as far as depth goes) in shadow, have an intense light in the foreground and another more diffused one for the background. There is of course no fixed rule for this, as it depends on cases, but there are a series of devices which can be borne in mind and which enlarge our options in this field.

DEPTH OF THE IMAGE

In the example on the right-hand page, a view of a canal in Venice, we see an interesting combination of perspective treatment of the buildings together with the reflections in water characteristic of subjects such as seascape. The observer's point of view is raised, so this is an aerial perspective. The arrangement of the boats alternating on the left and right side of the canal helps to suggest the depth of the image, at the same time giving it greater visual dynamism. Similarly, in the successive steps we will see how the use of color can help to emphasize the foreground, strengthening the perspective effect. As you can see in this composition, the line of the horizon is not visible, being wholly hidden by the houses; this however presents no difficulty, since we can guide ourselves by the vanishing-point.

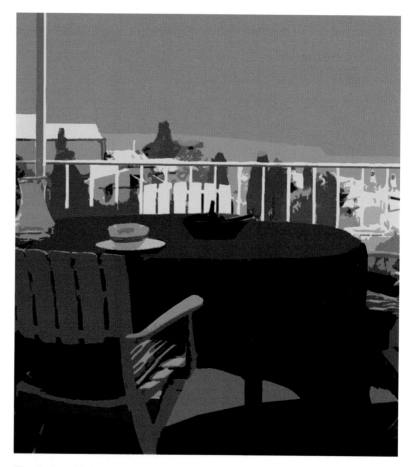

The shading of lights and darks by using gray tones is present as much in black and white drawings, like in the previous example, as in colored work.
In this illustration you can see three differentiated sectors: the terrace in the first place, a series of houses further away, and a mountain in the distance. The foreground has been left very markedly in shadow, the middle distance has a very intense, direct lighting, and the background presents a more diffused and less contrasting light.

As can be seen, all these lines converge on the same point. That is not the case with the houses beyond because they are oriented differently, so their respective vanishing-points fall elsewhere. As usual, the other houses also need to be drawn with a vanishing-point as a reference, even if it is only approximate.

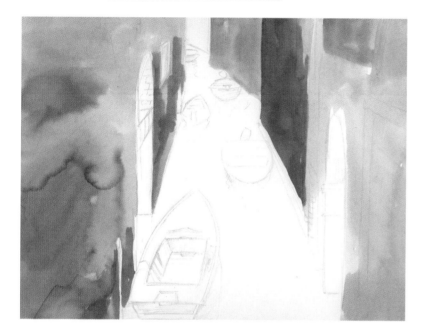

We begin to paint applying with a very diluted wash a light coat of a reddish brown tone. This coat just serves as a guide for the subsequent shading of the colors to be added in such a way that their tones harmonize and that the painting has a certain chromatic unity.

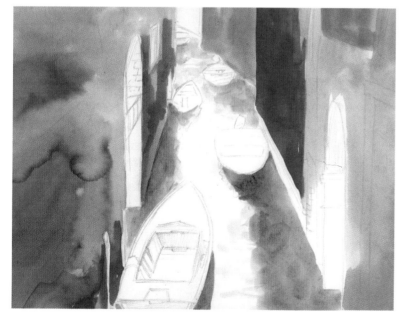

For the water we apply a blue tone, slightly darkened. If this blue were too pure (i.e. a very saturated tone) the contrast with the reddish color of the walls would be excessive and the painting would give a very unrealistic and over-colored effect. The central area of the water is left white to show the reflection of the light on its surface. This grading down of tone towards the central part has been done with separate horizontal strokes to imitate the effect of waves on the water.

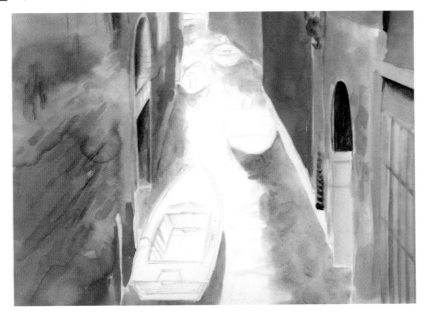

Continue to apply a first stain to features like the doors of the houses, the bars on the right or the moss on the walls. Before we apply large stains of final color it may be useful to put in the different tones (like the green of the moss) to see how they interact with the other colors of the composition..

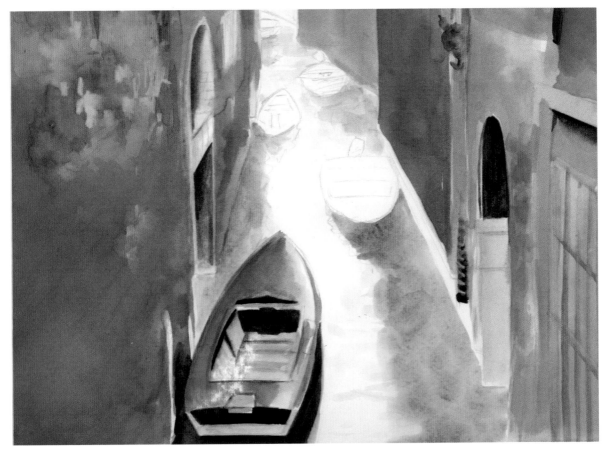

The tone of the walls in the foreground is now stronger, as the wash has been applied thicker so that this area comes out towards the viewer. By contrast the houses in the distance have bee n left with more transparent paint and less saturated colors. The nearest boat also needs to be treated with more detail than the rest.

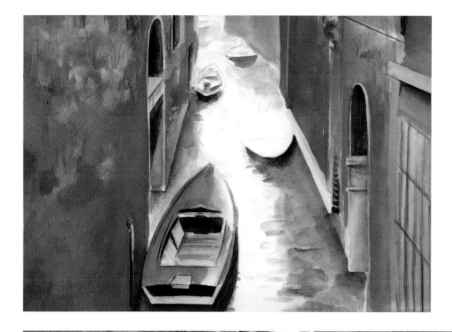

The contrast between the reddish tone of the wall, the blue of the water and the green applied to the wall on the left gives a greater feeling of depth to the scene. The hollows of the doorways have a fairly dark tone, since the sun is in front (though it is unseen) so that these areas remain in shadow.

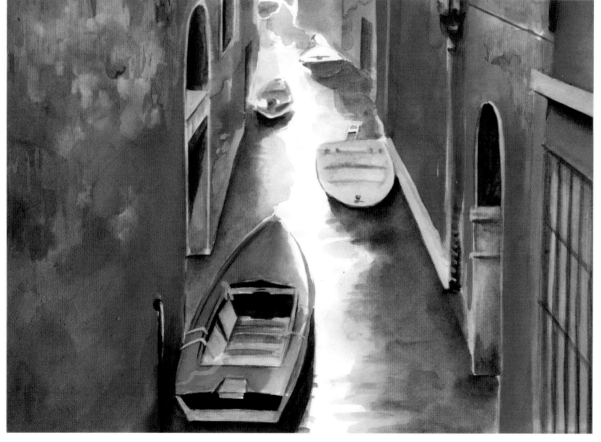

This is the final result. The effect of depth is suggested by all the factors we have described before. You can see that the undersides of the boats cast the darkest shadows to be seen on the surface of the water. On the other hand, in the area of the water and even on the houses in the background, the white of the paper has been left untouched and the painting is very diluted and with a spontaneous finish.

The banks of rivers are a perfect excuse to make studies of reflections, likewise of the line of the horizon.

In this case we can see that the reflection is a product of a narrow fringe of vegetation running along the picture from left to right, with two large masses of foliage standing out in it. We begin by tracing a simple outline in charcoal of the general shapes. The horizon line placed fairly high in the composition.

The reflections in the water are also drawn in approximately, to make the later work in color easier.

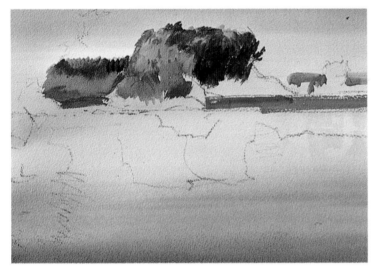

Then we apply color to the paper. We do this by means of general washes of very diluted water-color, applying successive horizontal coats of superimposed colors which blend in a subtle way.

Notice that the brightest area is that of the sky in the background of the picture, so we leave in this part a fringe where we apply hardly any color.

Then we apply color in the central area of vegetation. We begin by using a light green tone which we will progressively shade with a darker green.

The grass nearest the river bank on the right side has a warmer tone, so we apply a mixture of ocher and orange, but not too intense.

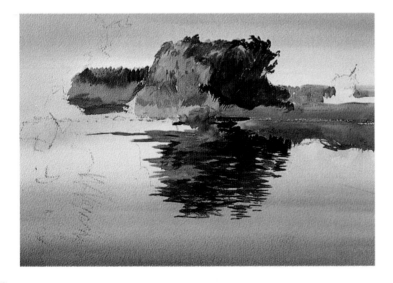

With the same warm color we used before to paint the shore, we now stain in its reflection in the water, but its tone is slightly darkened with a little more green, without altering the color.

We also begin to paint the reflection of the trees in the water. The reflection is achieved by means of small horizontal strokes which define the shape of the trees roughly but upside down. First paint with bladder green mixed with Hoocker (or dark) green and blue. As we go down the reflection we use fewer dark tones.

Continue in the area of the reflection; this time its brightest part is begun in bladder green without darkening, to establish the necessary contrast to the darker area.

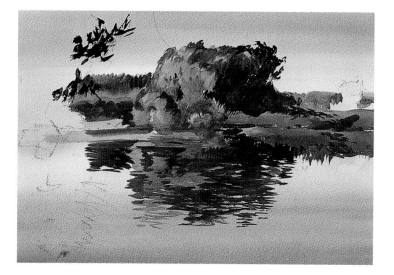

The motif of the reflections is given depth with a dark green coat on which we paint some direct strokes of the same color but much denser.

Dark patches are established in the group of trees. To paint the deepest shades of these trees, dark blue is mixed with green; some notes of dark blue are also painted in the area of shadow, but in this case it is not mixed. The first branches of the vegetation on the right are begun.

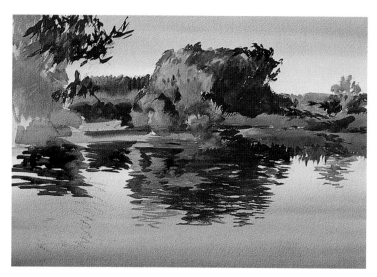

Work is now concentrated on the right side of the picture; first, we stain a yellowish tone mixed with ocher and a little blue to make it cooler. The stroke used is a quick and flowing one. This yellowish color will be the background to a subsequent work of brush-strokes, and can therefore be left without detail. Continue in the upper left corner, where the dark leaves are painted over light green.

Paint the tangle of the branches and leaves in the left area of the picture. First draw the main branches with the brush, and the smaller branches emerging from these which turn into small blotches representing the leaves. At the bottom of this clump of vegetation, paint a dark blue. The reflections in this area are depicted in the same way as the central glitters, but with a visible variation in the tone of green chosen.

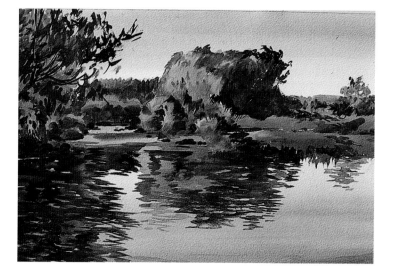

The tone closest to the bank is made much darker than the middle tones; the brush-strokes shaping this area of reflections are horizontal and short; some warm stains are also sketched which will serve as a base for the further representation of the reflections in the water; notice that some areas of the surface are allowed to breathe. On the right of the landscape some touches of bright blue are added. The area of the vegetation and reflections on the left is finished; the tangle of leaves in the upper part stands out from the yellow by its detail and its dark tone. With this last part the balance between the different masses of light in the picture is completed.

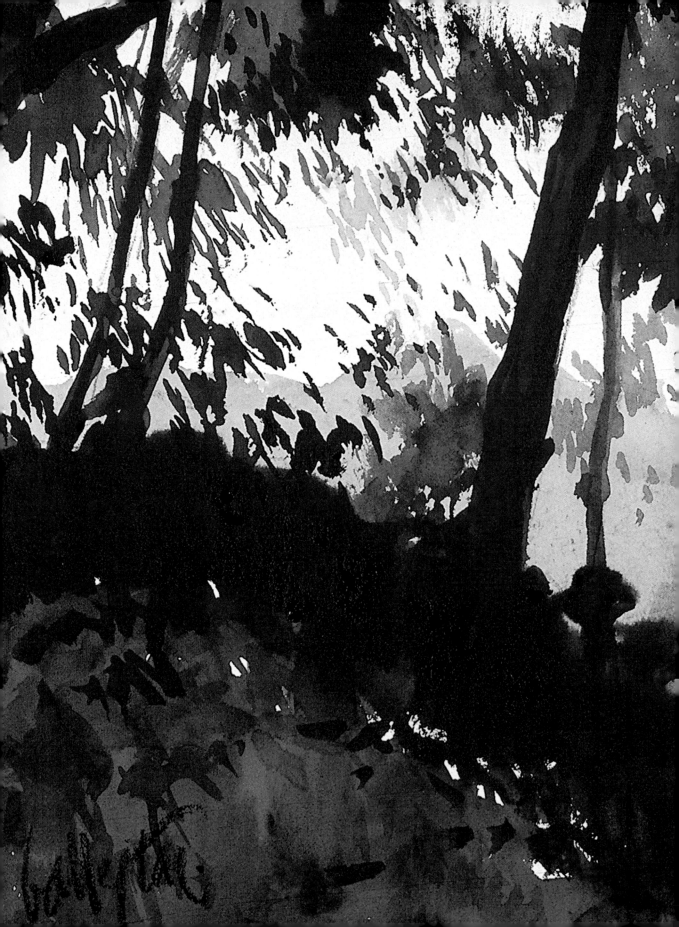

Exercises
Step by step

Urban landscape

Opening whites

Materials required

Crayons (1), paper (2), cloth (3)

The urban landscape is an pictorial theme with a great tradition among amateur artists; in fact any corner of a village or city may serve as a model for painting. A good drawing technique may be the key to the conception and execution of a good picture.

Throughout the unit simple skills have been presented with which to begin painting urban landscapes. To put them into practice, there could be nothing better than this street of a large city. As you can see, the long straight streets lend themselves to the design of a perspective with a single vanishing-point.

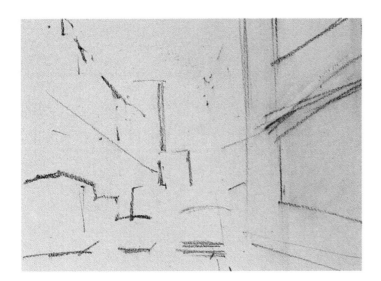

 1

Firstly the lines of perspective need to be worked out. As can be seen in this first sketch, all the planes of the buildings are defined – both above and below – by lines which tend to come together at a point. This first sketch does not require strongly marked lines. However, those who have not reached the necessary skill in drawing ought to trace a series of lines of perspective to serve as a basis for the design of planes.

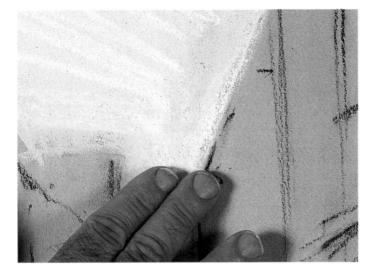

 2

Once the sketch is finished, begin by coloring the area of the sky; first color this area with a very bright yellow. Stain over the base color with white and rub your fingers over it to blend the white into the yellow. The result is a dense color characteristic of haze, which is so common in many cities.

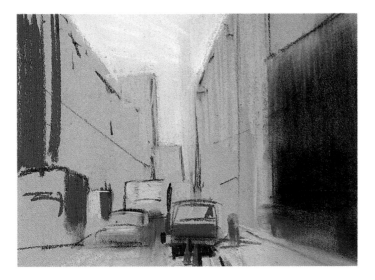

 3

As a colored paper is being used, it is a good idea in this urban landscape to take advantage of the interplay of the paper with the colors used. If we allow the surface color of the paper to breathe through in some places, we can set up an interesting rhythm between tones and colors.

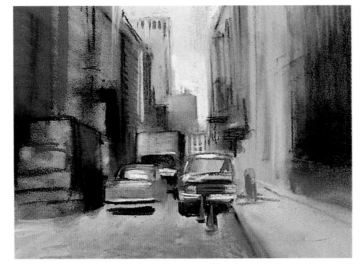

 4

Notice how form is given to the different planes of the walls with a very dark gray tone. The areas which need to show up bright are outlined with this color. Those areas correspond to the color of the paper. Areas of shine are made with bright strokes of gray.

Start painting the vehicles with bright tones to contrast with the dark ones.

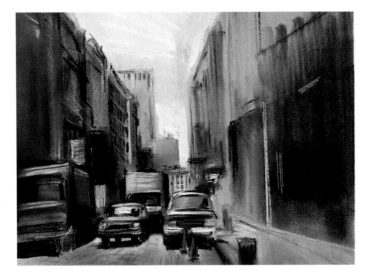

 5

When drawing in crayon, it is very important to take advantage of the surface color as one of the range of colors employed; that way you can achieve a large area with just a few additions of shine and contrast, as in this case. On the dark parts of the buildings on the left are drawn some touches of pinkish color, not too dark so as not to make the contrast too strong.

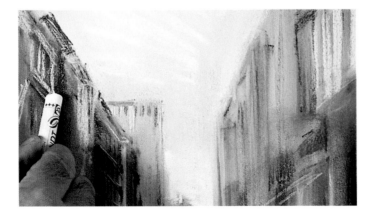

 6

With a very light cream color, paint the windows of the store on the right. Perspective becomes very important again: notice how the line of the windows follows the same direction as the other perspective lines.

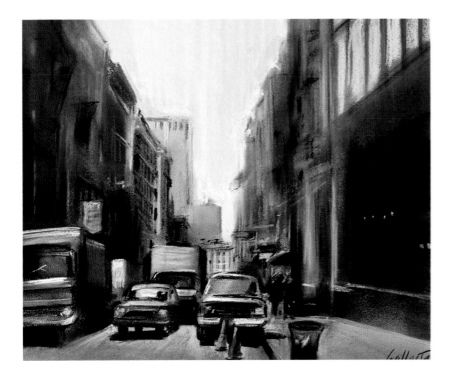

To complete this exercise, put in the final contrasts over the windows on the left, adding some small bright touches over them. At one of the edges of the right-hand window, the reddish pipe is drawn in a single stroke. Rub a hand over the upper area of the buildings on the left to dull the strokes just put in and incidentally convey a thick and distant atmosphere.

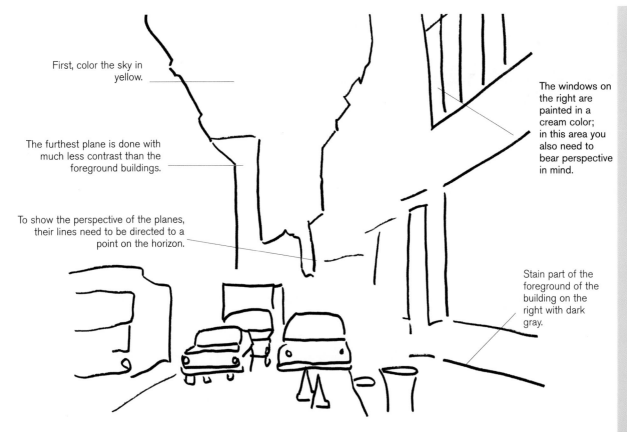

First, color the sky in yellow.

The furthest plane is done with much less contrast than the foreground buildings.

To show the perspective of the planes, their lines need to be directed to a point on the horizon.

The windows on the right are painted in a cream color; in this area you also need to bear perspective in mind.

Stain part of the foreground of the building on the right with dark gray.

Summary. STEP BY STEP

Mountains
Dry on damp

Materials required

Water-colors and palette (1), paper (2), brushes (3), charcoal (4), jar of water (5) and cloth (6).

As has been studied in the course of the various units, water-color is a transparent medium, and colors therefore need to be applied in order of their opaqueness, so that the brighter areas are enclosed by the darker ones.

Nevertheless by opening out whites you can restore brightness to an area previously darkened. By this means you can paint not just clouds in the sky but textures of all kinds.

This task consists in painting a landscape with water-color technique and leads to various exercises practicing the opening of whites.

 1

In all painting work it is very important to define sufficiently each of the areas to be painted before the first color is added to it.

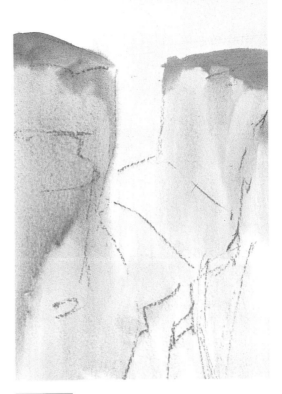

 2

The vertical position of the paper is very important when working on a damp surface; the color runs down the slope of the dampened paper.

Before it dries, start painting with ocher over the walls of the cliff and with green over the vegetation at the top.

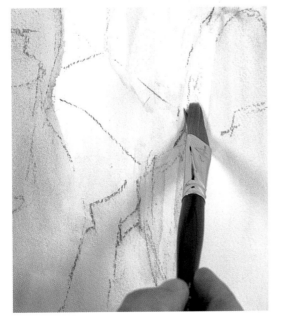

 3

On the freshly painted background, stage 3 involves making the first opening out of whites with a clean and slightly dampened brush; make a number of vertical strokes in the stone walls to clear the first lighter areas. If the color is too wet, the area you have just opened out will flood with color again.

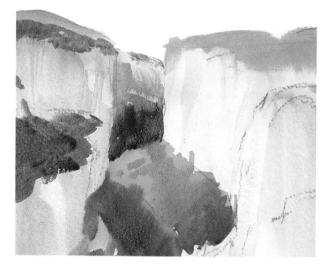

 4

The main clear areas have now been opened out; now, in stage 4, before applying the first dark colors, let the surface of the water-color dry completely to avoid the colors mixing.

First paint the dark colors of the upper part of the cliff; on the background paint blue tones, over which you pass the brush to open up lighter areas. Two tones of green are used: one lighter and brighter, for the background of the cliff, and a darker one for the areas of shadow.

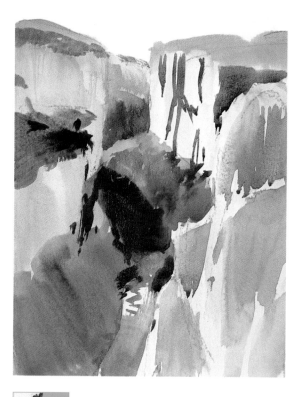

 5

Prepare a mixture of violet and cobalt blue to paint the rocky wall on the right of the background. With this tone, but a good deal lighter, paint the darks of the nearest rocky wall.

6

The river is painted with a very dark blue, but allowing glimpses of the earlier tones, now dry, and the white of the paper. The vegetation on the left is brought out in contrast with dense dark greens.

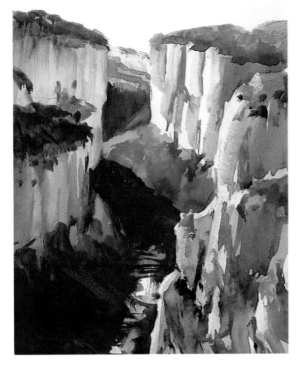

With a greenish color mixed with ocher, begin painting the wall on the left. As the surface is completely dry, the new color acts as a transparent coating, but dark enough to alter the color of the background. Before this new coat dries, rinse out the brush and make a number of passes to open up clear spaces.

In this last stage the stronger contrasts are applied on the rocky walls; some places are painted with ocher, they are left to dry and painted over with a very controlled wash of dark blue.

Lastly, with a clean damp brush again open up very bright white spaces in some areas of the rocky wall.

The background of the cliffs is painted over a wet surface.

In the upper part of the cliffs, paint the vegetation, letting it blend a little with the color of the walls.

On the rocky walls, open up light spaces with a clean and slightly dampened brush.

The last opening up of whites over the rocks on the right helps to increase the strong contrast of tones.

To paint the dark parts which define the rocks, the surface needs to be completely dry

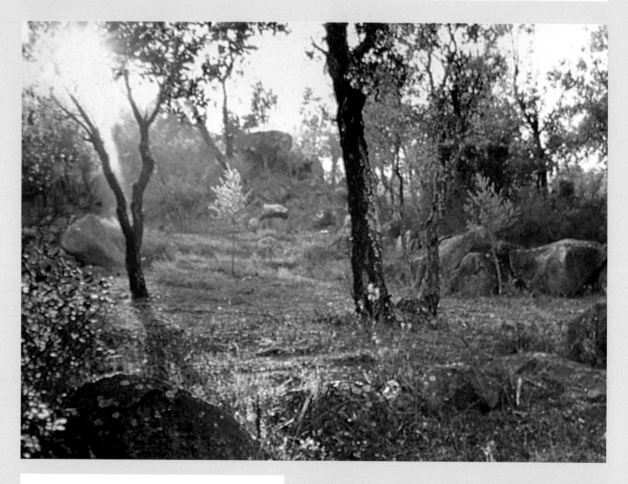

Materials required

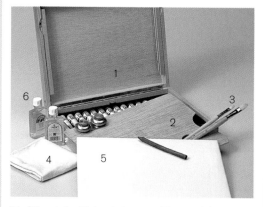

Oils (1), palette (2), bristle brushes (3), cloth (4), cloth-covered carton (5), essence of turpentine and linseed oil (6).

The outline is no more than a guide helping to represent the shape of the objects. If you know how to draw a circle, a rectangle and a triangle, you are in possession of the necessary tools to start drawing more complex elements and shapes.

The following exercise is in fact based on outlining, because starting from a triangle, a pair of rectangles and an oval you will be drawing a flower-pot with a bunch of flowers. This is a simple exercise, though it demands special care when it comes to drawing the various geometric shapes, which are the foundation for the whole drawing. Bear in mind that the exercises proposed in each section assume the notions applied in the earlier topics; so in this case we assume a knowledge of how to paint with the flat and with the tip of the brush.

 1

The landscape is begun, as usual in oil work, with a simple outline in charcoal. This permits any sort of correction with just the twist of a hand; moreover when you paint over it the line is naturally absorbed by the oil color without leaving any visible trace.

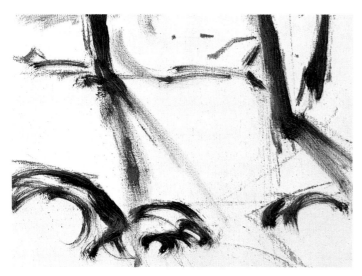

 2

Over the charcoal outline now paint with a very dark violet; these strokes will follow exactly the preliminary ones in charcoal. With these first strokes the trees and the basic lines of the picture are defined.

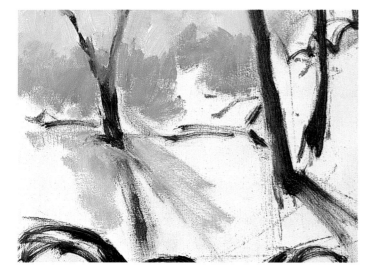

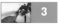 **3**

Paint the first large contrast, which brings out the backlighting effect. Mix Naples yellow with golden yellow on the palette. Without staining very thickly, paint all the background, outlining the shape of the trees.

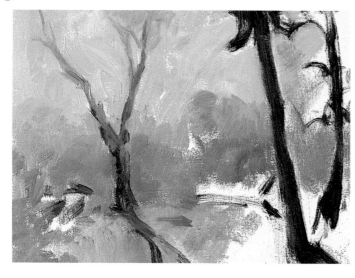

 4

Next paint the ground with long orange strokes; in the background, enrich the vegetation with bluish colors toned down with Naples yellow. The same colors are brought to the dark area of the foreground, where a little crimson is added. The shade of the tree is painted with crimson.

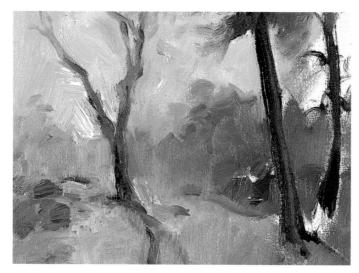

 5

Add thicker and more impasted brush-strokes and the picture makes progress. In the upper layers, when a more fluid color is wanted, use linseed oil instead of essence of turpentine.

The brush-strokes of the grass area are short and directed so as to suggest the texture; the yellow and orangish colors that form it are slightly dirtied in the right-hand area.

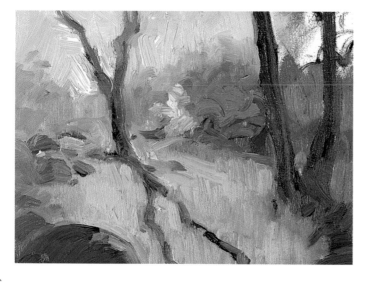

 6

In the background vegetation paint with very bright strokes of light violet; at the same time as you put in the complementary colors, do the same with the contrasts between the tones: a bright color placed between dark tones makes the darks seem deeper and the light parts more vivid. The trees receive reddish brush-strokes which contrast strongly with the blue and violet colors.

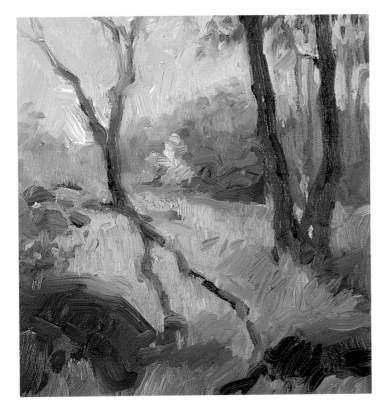

The upper right area is painted with many dashes of violet color alternating with small strokes or orangish cadmium yellow. The trunks receive thick red strokes which will serve as a complementary color to the greens painted in the lower area.

Lastly add some small touches of pure orange to conclude this landscape, in which the colors of nature have been interpreted in complementary colors.

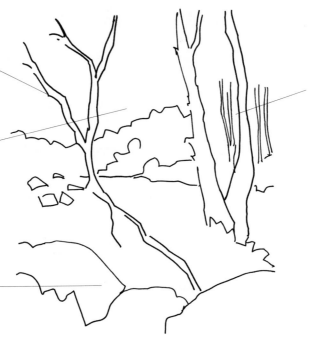

The outline is done in charcoal, and then in violet

The background is painted in yellow mixed with Naples yellow, to create a backlighting effect.

Paint over the trees with reds which are complemented by the greens of the lower area.

The ground is painted in orange colors which contrast strongly with the violet.

Seascape
The sea as protagonist

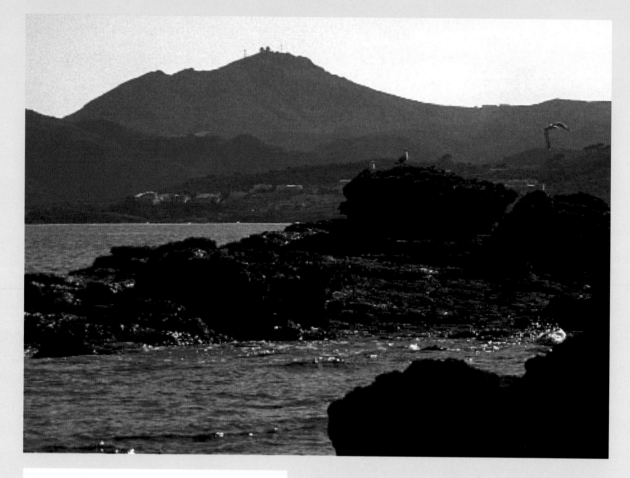

Materials required

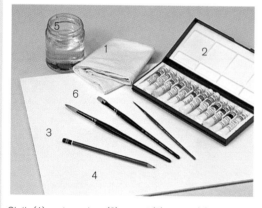

Cloth (1), water-colors (2), pencil (3), paper (4), water (5) and brushes (6).

Seascape painting can be an enthralling activity. In fact many artists devote themselves exclusively to this subject because they have found this the way to express their creativity.

Seascape can be approached from very different points of view, concentrating, for example, on a view in which only the sky and the sea are to be seen as the leading features, or on a subject in which rocks or a reef control the composition. In this task we are going to develop an interesting seascape with rocks; the difficulty involved is not excessive, and as you can see the result is of great artistic interest.

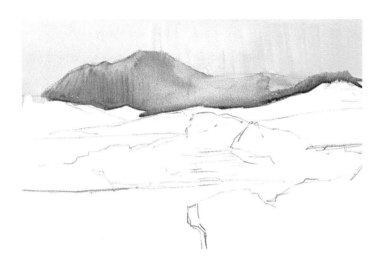

1

As you have learnt in this unit, when it is a question of capturing the horizon, a seascape may be sketched with a simple line; but when you include reefs or some other feature emerging above the surface of the water, it is important to make a careful preliminary drawing of each of the rocks, so as to avoid painting by mistake some area which does not belong to them.

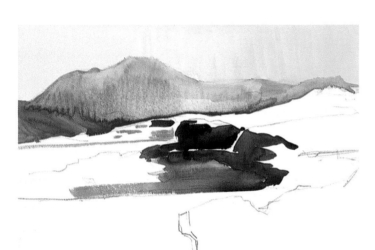

2

Immediately after painting the mountain in the background, paint the next plane of the land, which, being nearer, shows greater contrast than the former. As you can see in this image, the first yellowish wash makes the mountains that have been painted over it in a transparent tone seem to be enveloped in a hazy atmosphere. On the other hand the lower and nearer mountains can be seen as much darker and clearer.

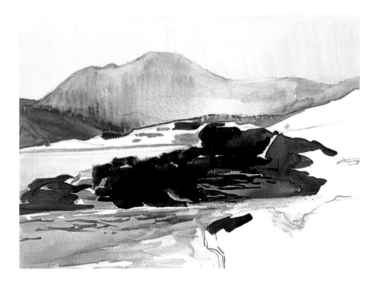

3

Once the shadow between the rocks has dried, paint the rocks themselves; they should not be a great problem because, as they are quite dark, their shape can merge together. With the same tone paint the dark reflections of this area with strokes that edge the color below.

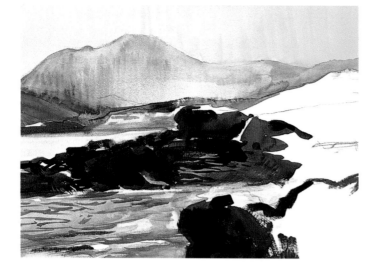

4

It is important not to make the waves in the foreground of the water just a simple block, but allow for a certain elasticity and imprecision in direction. The color of the rocks in the foreground needs to have sufficient contrast to be visually separated from the rest of the background tones.

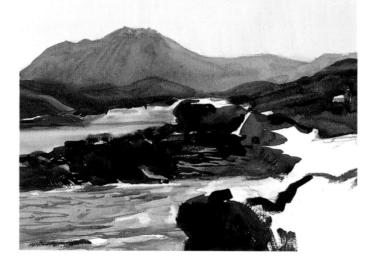

5

The mountains on the right are painted with a greenish slightly dirty tone, mixed with violet. In this area, leave blank the light part belonging to the little white house. The difference between the plane of the water in the foreground and the further plane is obvious; now, on this second plane paint with a blue wash. Go over the line of the horizon with successive strokes of the brush till it is well defined.

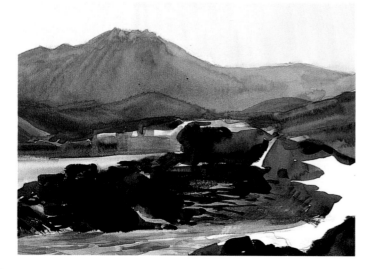

6

On the plane of the village in the background, apply some contrasts in violet a little darker than the background. On the foreground of the sea, apply successive brush-strokes with a very transparent cobalt blue. With these strokes you keep in reserve some bright areas which will act as shining ripples; some areas have remained very luminous since the beginning stages of the picture.

Finish painting the rocky outcrop in the foreground, though its color is not yet final.

On the water in the foreground paint new contrasts in cobalt blue; this time the reflections appear much brighter and more luminous. Now finish the central reefs in the same way as you began them. The unpainted remainder of the stone is stained with a transparent wash of toasted shadow color. When this coat is dry, paint over it again with the same color, allowing the lower tone to breathe in a few places as tonal variations of the stone.

A very dark addition of toasted shadow color on the rocks in the foreground completes the seascape.

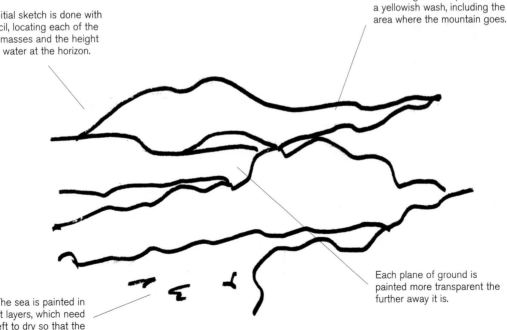

The initial sketch is done with a pencil, locating each of the rocky masses and the height of the water at the horizon.

The background is painted with a yellowish wash, including the area where the mountain goes.

Each plane of ground is painted more transparent the further away it is.

The sea is painted in different layers, which need to be left to dry so that the lower colors can breathe without mixing.

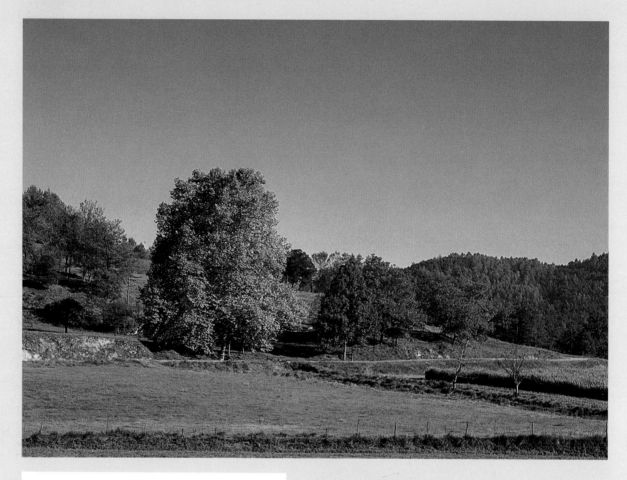

Materials required

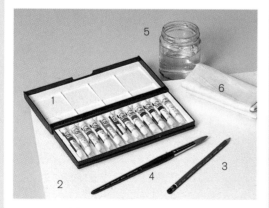

Water-colors (1), water-color paper (2), pencil (3), brushes (4), jar of water (5) and cloth (6).

The landscape painter is one of the artists who most enjoy their work. For one thing, there is the freedom of working in the open air in contact with nature; another is the results you obtain when practice and technique finally turn into art.

Landscape allows for a variety of actions which other genres, like figure painting or still life, do not include. Even though the beginner may often work from photographs and from the models provided in these pages, once he has developed the first skills he ought to venture out with a notebook and some water-colors and carry out on the ground paintings like the ones we are going to tackle now.

1

Although it is possible to paint directly in water-color without a first sketch, it is not very advisable because in this technique the procedure requires you to avoid painting the areas which will later stand out as the brightest.

Pencil permits a clean, free drawing, sketching very rapidly the shapes which are going to be covered with the gouache.

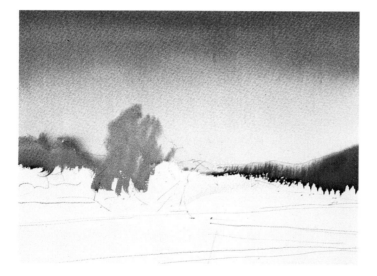

2

First, with a brush soaked in clean water dampen all the area of the sky. Once the paper is quite wet, paint a thick fringe in the upper area; the dampness of the paper makes the color soak downward in a gentle shading-off of tone. Before the background dries, paint the darks of the horizon. As the paper is vertical, the color will not seep upward, but its edges will be blurred.

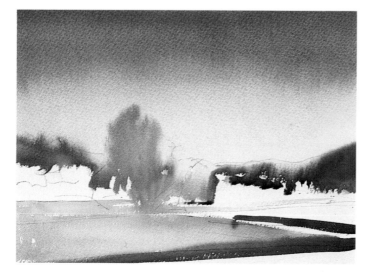

3

As only the upper part of the picture was dampened, the whole lower part has remained intact to be painted afresh.

Dampen just the central part of the ground area. Over this area paint another wash, so that it spreads rapidly all over the wet surface. Part of the color of the previous wash has come into contact with this area and the two parts have joined. On the part closest to the ground paint a dark fringe.

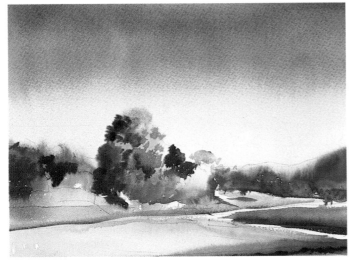

 4

Once the upper area is completely dry, you can apply on it very well controlled brush-strokes, without the stains mixing with the lower layers.

Also paint the other two sections; on the right-hand one a darker tone is used, and it is painted leaving a gap so that the tones don't mix, since the central section is still damp. On the other hand the foreground part is painted allowing the dark upper fringe to blend with the tone.

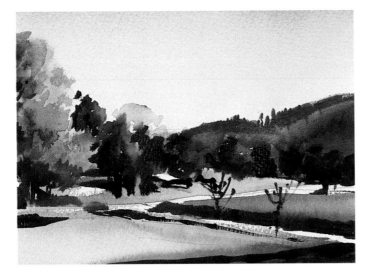

 5

On the dry surface, lines and stains are painted which allow the shape to be drawn and the different planes to be separated.

The trees on the ground at the right are drawn with thin lines, without any blending with the reduced tones of the layers below.

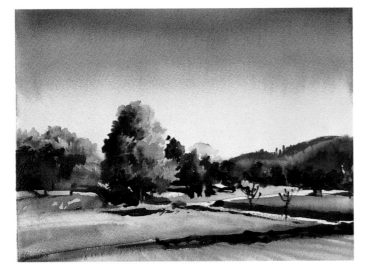

 6

The more precise details are depicted on the completely dry background so that the tones do not mix. These strokes are made in a drawing style, applying small dark stains superimposed on the initial tones.

With the brush loaded with a thick tone the deepest areas of the areas are contrasted.

 7

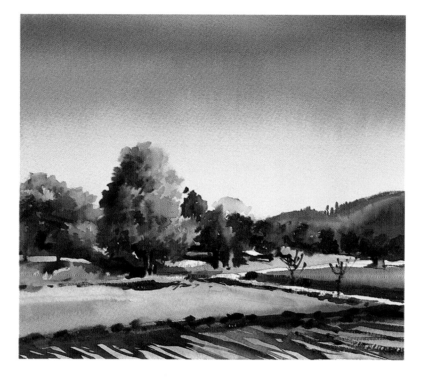

All that remains is to apply some final touches which give a little more contrast to the trees in the background.

The texture of the ground has been begun entirely on a wash base over which some thick dark lines are traced. Now the color of the background wash becomes a luminous tone.

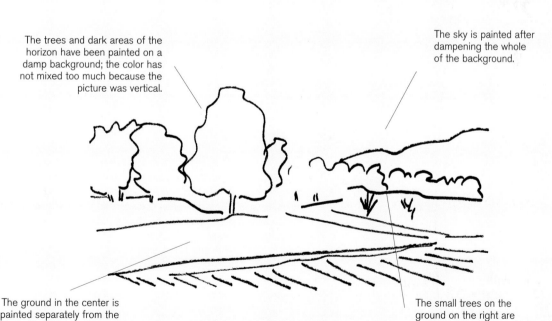

The trees and dark areas of the horizon have been painted on a damp background; the color has not mixed too much because the picture was vertical.

The sky is painted after dampening the whole of the background.

The ground in the center is painted separately from the rest so that the tones do not blend.

The small trees on the ground on the right are painted with clean strokes on a dry background.

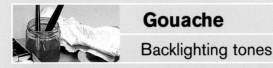
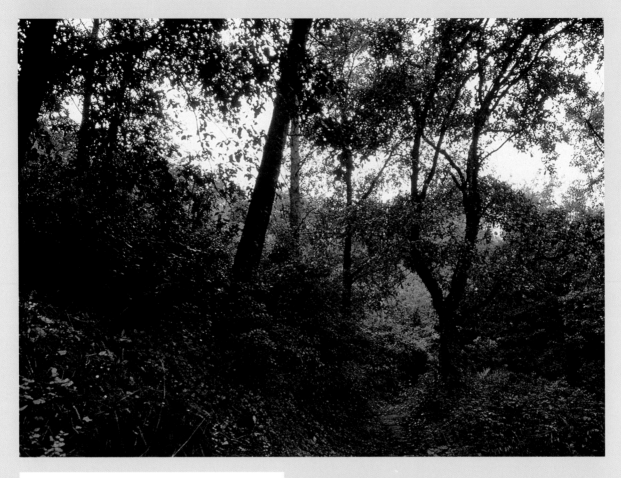

Materials required

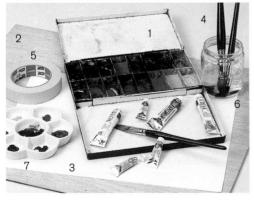

Water-colors (1), support (2), medium-grain paper (3), brushes (4), sticky tape (5), jar of water (6), and palette (7).

The technique of gouache enables water-color landscapes to be painted with a great richness of tones and shine.

The following exercise takes as its model a photograph of a dense area of wood. In this image, the light filters through the foliage and prevents the details and textures from being seen clearly; you only see a variety of tones of an almost monochrome color.

Only one color will be used in painting this landscape, thus giving practice in the gradation of tones in gouache. This is a very simple landscape to paint, as you only need to pay attention to the tonal areas of the picture. Besides, as we are using a photograph as a model, the framing and composition are already settled.

 1

In the initial drawing just place the principal compositional elements of the landscape. This drawing will help to separate the tonal areas.

You need to look for a slight asymmetry in the elements of the landscape.

In this first step, leave out the branches and leaves, which will be painted later directly with the brush.

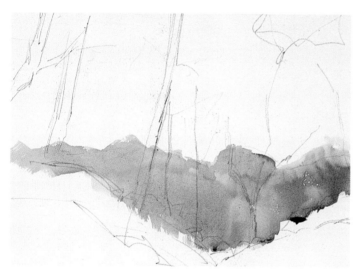

 2

Using just one color enables the center of interest to be established in the treatment of the stains and in the sienna-colored tones.

To separate the planes of the wood, paint its whole background with a transparent wash of a single tone; draw with the brush the outline between the vegetation and the sky.

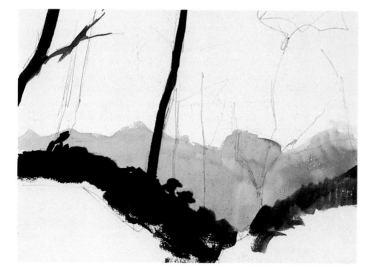

 3

Leave the background to dry and then add the dark tones. On the left paint the darker tone, which can be achieved with sienna; use a slightly damp brush to pick up the pure color from the palette, and paint without any toning down.

Draw the trunks of the trees with a delicate line. The whole stain formed by the mass of vegetation is painted with a very dark tone.

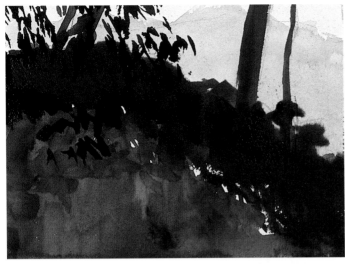

 4

Lighten the previous tone on the palette with a little water and paint the lower area till you have completely covered the two dark masses that divide the landscape into two. Paint the whole area quickly, treating the masses as simple stains.

Leave small points unpainted, showing the surface of the paper. Next paint the path with an intermediate tone.

 5

Once you have dealt with the main tonal masses of the wood, in particular the large dark stains of the vegetation and the ground, finish drawing the trunks of the trees and start on the foliage with dark, thick stains, very free and without outlines.

With a fine brush draw out, with short diagonal strokes, part of the tone while it is still damp, thus eliminating the outlines of the stains that have just been painted.

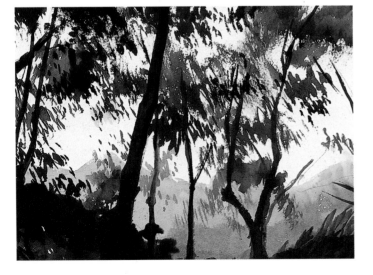

 6

If you stain any area by mistake, it should be integrated with the rest simulating part of the foliage. Paint some stains, taking care that the brush carries very little paint.

 7

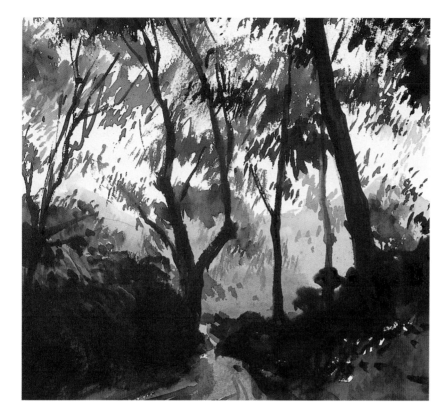

Draw small lines till the foliage is finished, with points of light showing through it which are merely small areas without paint.

Lastly, paint on the lower area some more, very dark stains which suggest plant shapes. With this you can finish off this simple landscape with a rich range of tones of sienna.

The lightest tone is the white of the paper.

This very dark tone of the vegetation has been achieved by painting the color almost without water.

The background tone has been obtained by adding a good deal of water to the pure sienna color.

To paint a dark area over a light one without the tones blurring, you need to wait for the first coat of color to dry.

Skies

Working with reduced tones

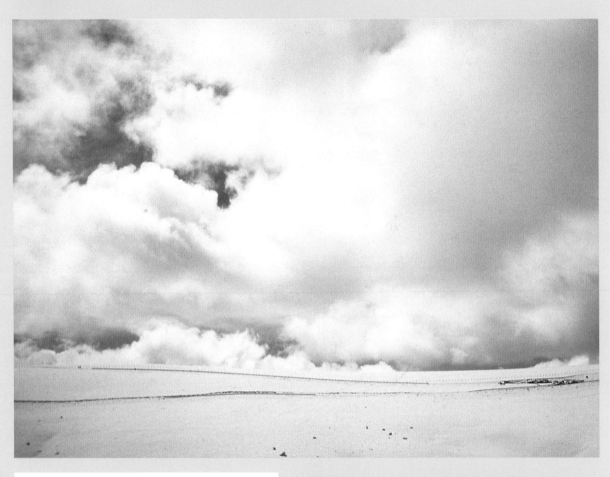

Materials required

Tubes of water-color (1), palette (2), pencil (3), water-color brushes (4), water-color paper (5), cloth (6), sponge (7), and jar of water (8).

More than any other artistic genre, landscape gives the artist the chance to practice all the techniques he has learnt, and with the advantage that there is no danger of such obvious errors as can arise in other genres. There is nothing better than landscape for practicing the superimposition of tones in water-color. In landscape, as we have been able to see elsewhere, it is easier to practice the different resources offered by gouache.

In this case we have chosen a cloudy landscape in which a great variety of tones can be seen in the sky. The white of the clouds is obtained, as usual, by keeping in reserve the color of the paper itself. The grading-down of tones is done through different additions of water to the color; in this way we can obtain the intensities appropriate to each area.

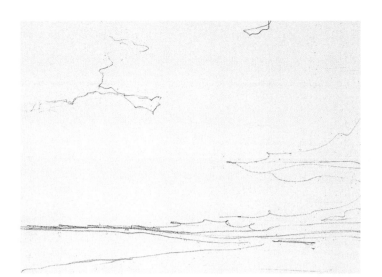

 1

A very simple outline of the landscape is made; all you need is some lines which locate the horizon in the lower part of the frame. In that way the landscape is centered on the area of the cloudy sky.

Also sketch the clouds with very faint lines. This first sketch needs to be simple and to outline the main elements with the necessary strokes.

 2

Make the first wash fairly bright, and stain the lighter tones of the grays in the clouds. Leave the whites untouched, for they will be the brightest area of the picture. With the background still damp, again stain with the same tone the area on the left; when you trace with a brush loaded with color over a newly-painted area, the tone darkens to the point of creating a strong contrast with the part below, which was already nearly dry.

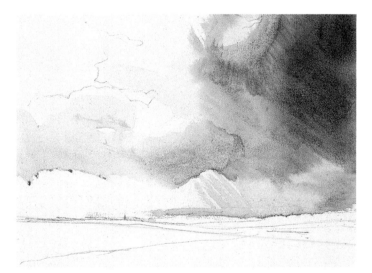

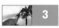 **3**

Increase the density of the wash on the palette by adding a little more color to the previous one. Paint over the previous tones, which are still damp in some places.

In the right-hand area the coat is still damp, enabling a very gradual increase of contrast to be made. The lower part of the sky is painted with the darkest blue, outlining the horizon with the brush.

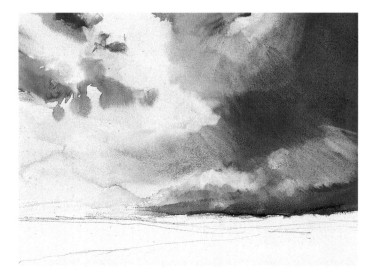

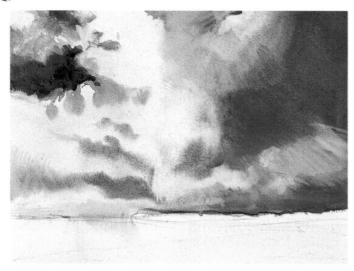

4

You need to wait for the upper left area to dry before painting with this dense blue tone.

As you paint darker tones, the middle ones painted earlier appear as much brighter than they were originally.

In the lower right part paint with a very light tone which melts on the surface of the paper.

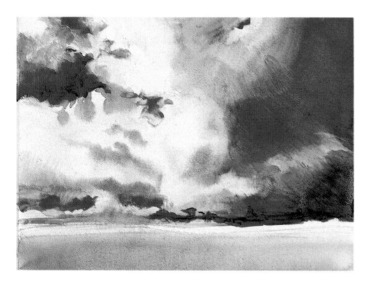

5

Wait for the background to dry before continuing to paint. When it is quite dry, paint the strong dark line of the horizon. With a rather lighter wash, also stain the intermediate tones of the low clouds.

In the area of the ground, paint with a very bright uniform wash; you do not need to reach the area of the horizon. This fringe, which is left white, stands out strongly thanks to the dark tones around it.

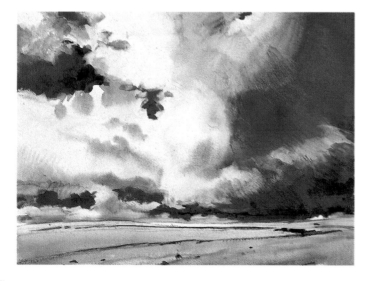

6

With small brush-strokes loaded with very dark blue, stain some of the areas of the sky where before there were middle tones.

In the lower area, belonging to the ground, trace some long strokes with a clean damp brush; this causes part of the color of this tone to be absorbed. Once this area is dry, paint some very fine lines with the tip of the brush.

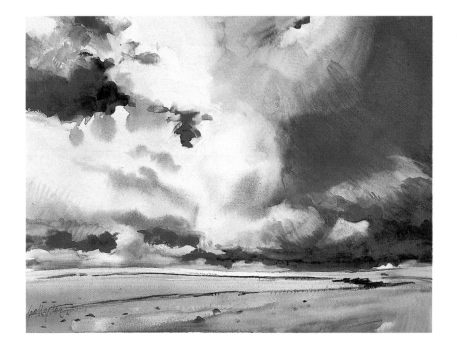

It only remains to clean a little white area in the lower right part of the clouds; you do this by passing a clean damp brush several times over that area.

This is how the finished landscape looks. The build-up of tones is evident in the progression of the picture. In some parts the tone has blended with others that were already dry; in others the brush-stroke has been applied with precision because the background was completely dry.

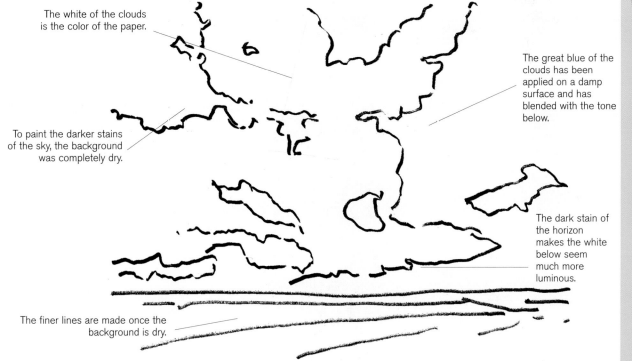

The white of the clouds is the color of the paper.

The great blue of the clouds has been applied on a damp surface and has blended with the tone below.

To paint the darker stains of the sky, the background was completely dry.

The dark stain of the horizon makes the white below seem much more luminous.

The finer lines are made once the background is dry.

Summary. STEP BY STEP

Landscape in chalks
Complementary colors

Two colored chalks (1), gray carton paper (2), and cloth (3).

When you draw with colored chalks, the paper serves as another color together with the range that you use, and is integrated into it. The following exercise consists in creating a landscape with two very different colored chalks, though they may be considered mutually complementary.

This exercise is done on carton, and the texture is therefore very different from that of paper; the color of the support will be a part of the tones obtained in developing the drawing.

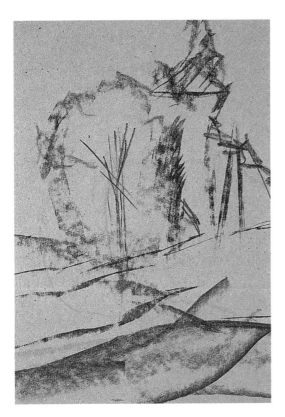

The sketch of the landscape consists in some preliminary lines situating the different masses of the model on the page.

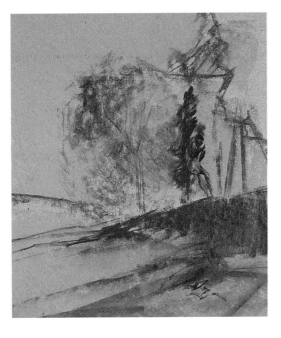

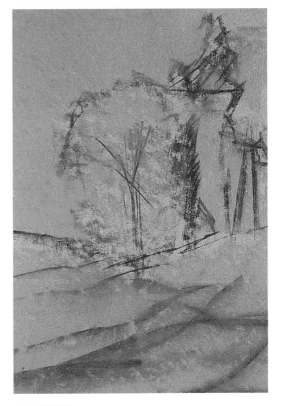

Chalk applied to carton adheres much more than on paper, though this coating of color may seal the already tight pores characteristic of this surface.

Begin to stain over the sketch, once it has been fully defined, with orange chalk; this application is also done with the bar flat between the fingers, without covering the surface of the carton completely; the color of the background stands out against the texture of the drawing.

When you paint with orange over the blue, the orange is drawn out, and the blending produces a slightly green color. The blue chalk will enable you to form the contrasts which define the shadows and the leading outlines of the landscape, while with the orange chalk you can bring in the necessary brightness.

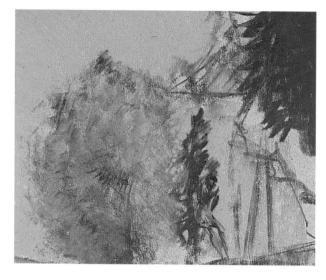

As can be seen, it is important to preserve the tone of the support in spite of the different applications of color. The darker contrasts, drawn with blue chalk, emphasize the little hollows where the color of the carton peeps through.

On the right of the picture paint with enough pressure for the blue to be thick and opaque. The tree situated in the center of the landscape is drawn alternating the two colors, which are next blended softly with the fingers, without quite rubbing out the line of the drawing.

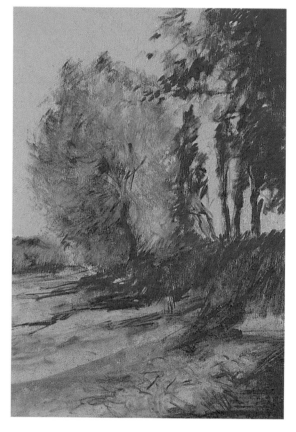

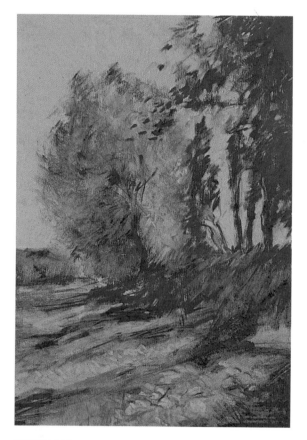

With the blue crayon, strengthen the contrasts in some areas. This should not be done evenly all over the drawing; in some places the orange color and the background should continue to breathe.

On the right, draw very gently with the orange chalk.

7

Gently blend the tones of the ground, and superimpose some more, very direct touches of orange.

Lastly, paint with blue the great mass of vegetation on the right, thus considerably increasing its size. The color of the surface breathes between the strokes and stains, and this landscape of strong contrasts is thereby complete.

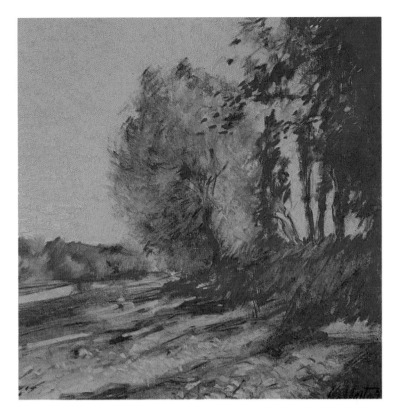

The carton is colored in orange; the chalk held flat between the fingers permits an open stroke through which the color of the surface can be seen.

The initial sketch is done with the chalk held flat between the fingers. The stroke tends to slip because the support has a very closed pore.

When you draw in orange over blue, the color below is dragged with the stroke.

Direct dashes of orange give brightness to the ground and bring out the complementary contrasts.

Open landscape

Toning the landscape

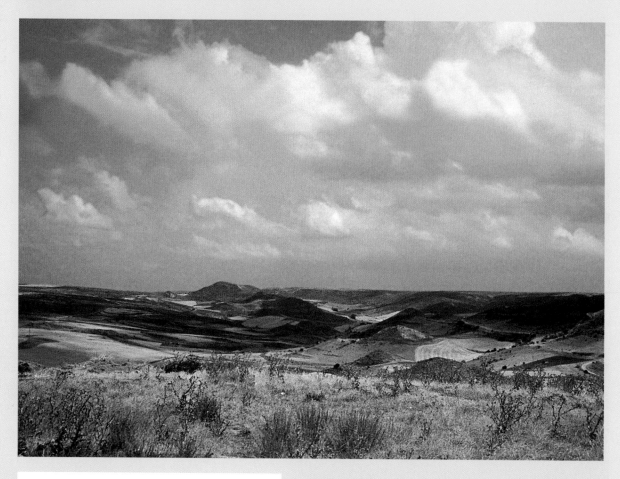

Materials required

Crayons (1), colored paper (2), and cloth (3)

Crayon is one of the most direct drawing methods there are, since it does not require any time for drying and it can always be taken up again in the same state it was left in the last time, so that it is constantly ready for retouching. Moreover no brushes are needed to spread the color over the paper, just the fingers, which can spread it very easily.

The aim of the following exercise is to practice line and toning, based on a landscape whose upper half is filled with a sky with abundant clouds.

 1

Begin the drawing by doing a sketch with the point of the crayon, using a stroke practically the same as with any drawing in charcoal or sanguine.

The lines ought to be very simple, and dominance needs to be given to the space occupied by the sky, for this is where the main practice of this exercise is going to be carried out. The paper chosen is cream-colored, which contrasts with the opaqueness of the crayons.

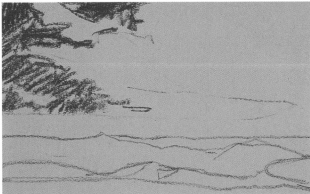

 2

Draw the area of the sky with a dark blue crayon. The stroke needs to be very free and flowing.

In this drawing the sky is not painted as a block but left with some spaces where the color of the surface (the paper) breathes through.

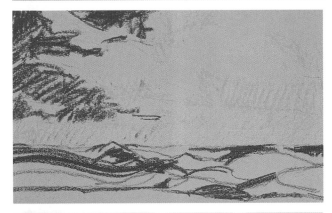

 3

Continue drawing the area of the sky with a sky-blue crayon.

Outline the shapes of the mountains with zigzag strokes of dark brown.

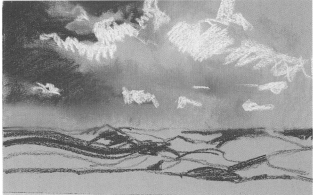

 4

Softly tone down the first lines with your fingers and paint the clouds of the sky with white crayon. The strokes need to be free, zigzagging and with a great variety of crossed lines.

You can see that the color of the paper contrasts strongly with the brightness of the white.

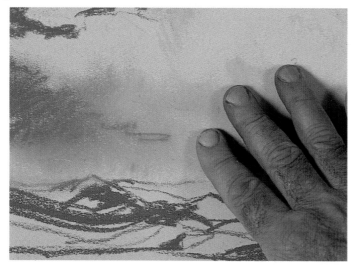

5

Once you have made the first strokes and stains on the paper, you can begin to blend the color with your fingers, but without pressing too hard.

Do not blend all the white on the paper, just the areas that are necessary; if you pass your finger all over the area colored, the line of the crayon will be rubbed out and the picture will lose its fresh and spontaneous character.

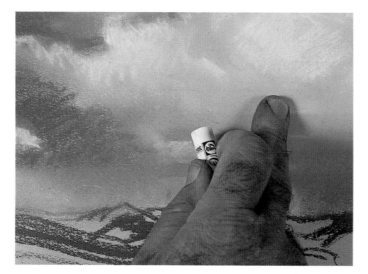

6

In this detail you can see how, without letting go of the crayon, you can use your ring finger to blur part of the white and blend the edges of this color with the blue.

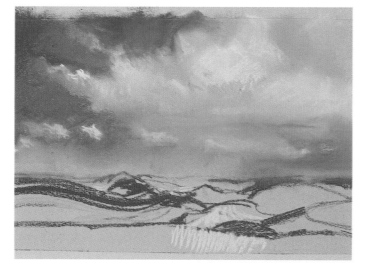

7

In the area separating the sky and earth, just on the line of the horizon, apply a stroke of very luminous pink. When drawing this line, do not press too hard with the crayon.

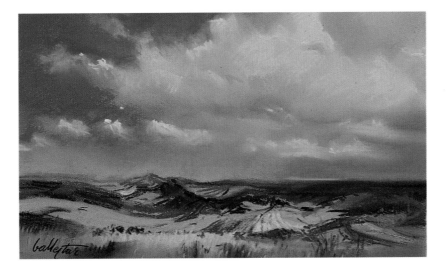

8

On the area of the ground, make a blend in vertical zigzags with greens and browns. Over these blended colors apply small very bright dashes of green. Leave some areas almost uncolored so that the surface of the paper breathes. In the background mix dark green and brown, which gives a dull dirty color. Lastly paint some stains of white without blurring in the area of the clouds.

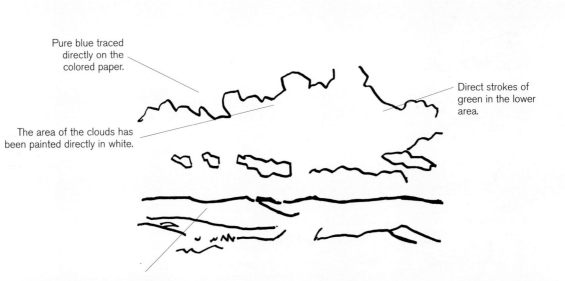

Pure blue traced directly on the colored paper.

Direct strokes of green in the lower area.

The area of the clouds has been painted directly in white.

Line of pink on the horizon.

A country lane
Loose strokes

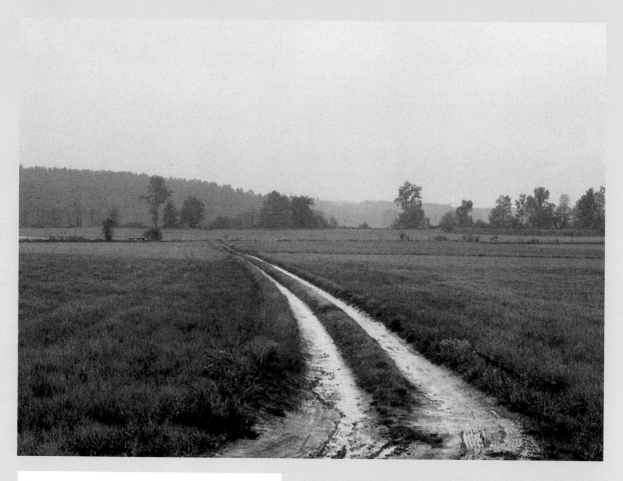

Materials required

Tube of water-color (1), water-color brush (2), water-color paper (3), pencil (4) and jar of water (5).

The model chosen in this case is a landscape, but it doesn't matter if in these first attempts the result is not very close to the model, as this is a mere excuse to practice what is explained in the unit. It is really to begin acquiring skill in handling the painting tools and also in making strokes, straight lines, curves and dots.

In this exercise, which will be done with the same color used in the exercises of the technical part, the most important thing is to observe how the different strokes are made, how the brush technique is managed, and how color behaves when progressively treated with water.

 1

Begin by outlining the area to be painted; for this use a pencil. Don't press too hard so as not to mark the paper.

One ought first to draw a pencil sketch of the subject to be painted, but in this case it is unnecessary as the important thing is practicing the brush-strokes.

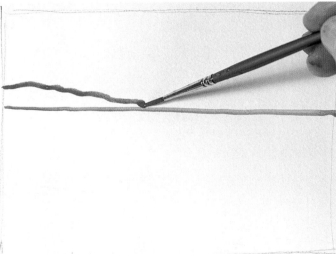

 2

After dipping the brush in color, draw a straight line. As you can see, the beginning of the stroke is finer; here the brush carried a lot of color. As the stroke continues the paint runs out and you need to press more with the brush, so that the line becomes broader.

Dip the brush again to load it with color and paint a new wavy line; this sketches the mountains in the background.

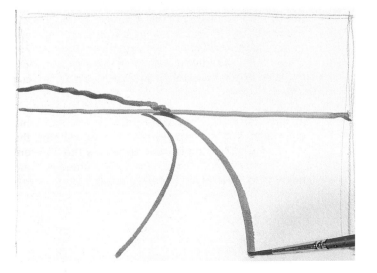

 3

Dip the brush again on the palette; if the color has run out, you need to make a new dilution with a little water and another small brush-full of water-color. Before you paint again, test on a separate piece of paper that the tone is similar to the one before.

Now paint a very wide curve without lifting the brush. To the right of it draw another curve, coming away from it as it lengthens.

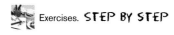

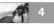
4

Dip the brush in water and pass it below the line depicting the mountain in the background; the color expands easily on contact with the newly dampened area. Where there is no dampness the color will not penetrate easily and will need to be brushed in; in other words the work will have to be done with the brush to attain the shape desired.

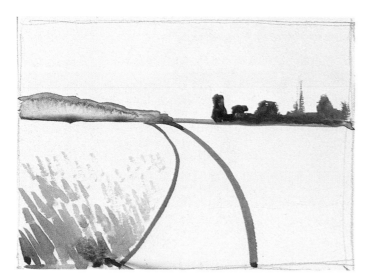

5

Wet the brush and make a lighter tone on the palette.

Paint short small strokes in the lower part, starting from below and going upward. As you paint, make the strokes shorter each time.

When there is hardly any paint left on the brush, finish painting the tiny strokes of the upper part. When the brush carries very little paint it leaves a distinctive trail.

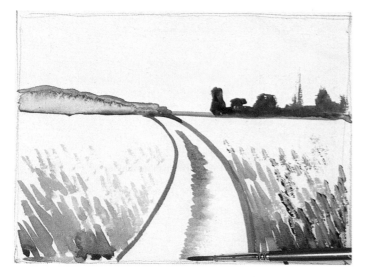

6

In the central part of the two curved strokes, paint from above downwards successive horizontal strokes, first very small ones.

As you go down, the strokes become longer.

Don't pick up more color; when it runs out, wet the brush with clean water and continue drawing out the previous tone.

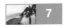 7

To conclude this simple exercise of strokes, dab points with the brush in the area which remained blank.

Also on the path, on either side of the central stain, trace small brush-strokes superimposed on the dark area of the center.

Making a line in a single stroke..
Before the color completely dried, it has been wetted again and has thus been made lighter.

Loose strokes.
The strokes of the foreground are longer and darker than the further ones.